Step-by-Step WEDDING PHOTOGRAPHY

Techniques *for* Professional Photographers

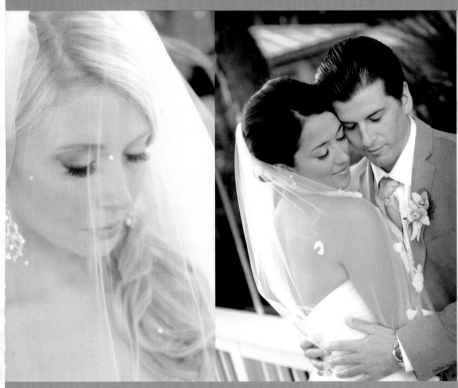
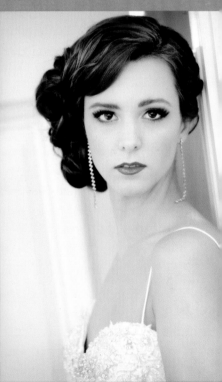

Damon Tucci

AMHERST MEDIA, INC. ■ BUFFALO, NY

Published by:
Amherst Media, Inc.
P.O. Box 586
Buffalo, N.Y. 14226
Fax: 716-874-4508
www.AmherstMedia.com

Publisher: Craig Alesse
Senior Editor/Production Manager: Michelle Perkins
Editors: Barbara A. Lynch-Johnt, Harvey Goldstein, Beth Alesse
Editorial Assistance from: Carey A. Miller, Sally Jarzab, John S. Loder
Associate Publisher: Kate Neaverth
Business Manager: Adam Richards
Warehouse and Fulfillment Manager: Roger Singo

ISBN-13: 978-1-60895-713-2
Library of Congress Control Number: 2014933309
10 9 8 7 6 5 4 3 2 1

Check out Amherst Media's blogs at: http://portrait-photographer.blogspot.com/
http://weddingphotographer-amherstmedia.blogspot.com/

Contents

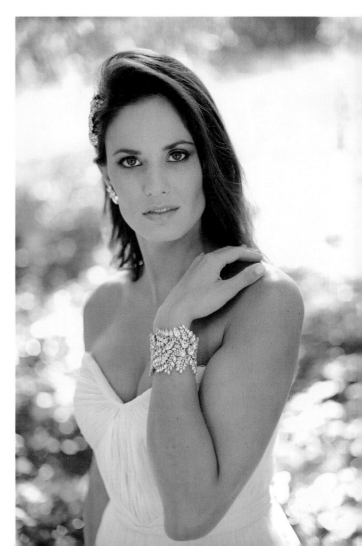

About the Author

*D*amon Tucci has been a professional photographer in the Orlando area for more than twenty years and has photographed over 2500 weddings. Unlike many wedding photos from the past, his images are emotional, unique, and interesting—just like the couples he photographs.

Damon's distinctive artistry is a combination of talent and experience. He began his career as an underwater cinematographer and later worked as a photographer for Disney Photographic Services. It was at Disney that he carefully crafted his unique approach to wedding photography, which features a mix of documentary-style photography and stylized fashion shots.

Damon's nontraditional method of blending fashion with documentation is revolutionizing the wedding industry. Today's couples don't want to spend precious hours on formal poses. They want to enjoy their day with family and friends. Damon's unique understanding of light allows him to capture these once-in-a-lifetime moments, but in an unobtrusive manner that does not disturb the wedding.

As an artist, Damon revels in breaking the rules. He firmly believes that if you don't enjoy what you do, you should do something else. His

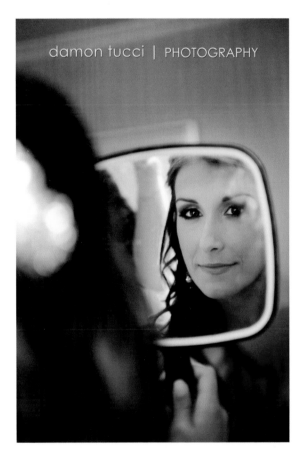

personality is laid-back and fun. Though he is highly professional, his sense of humor is always at the ready, and that makes working with him much like spending time with an old friend.

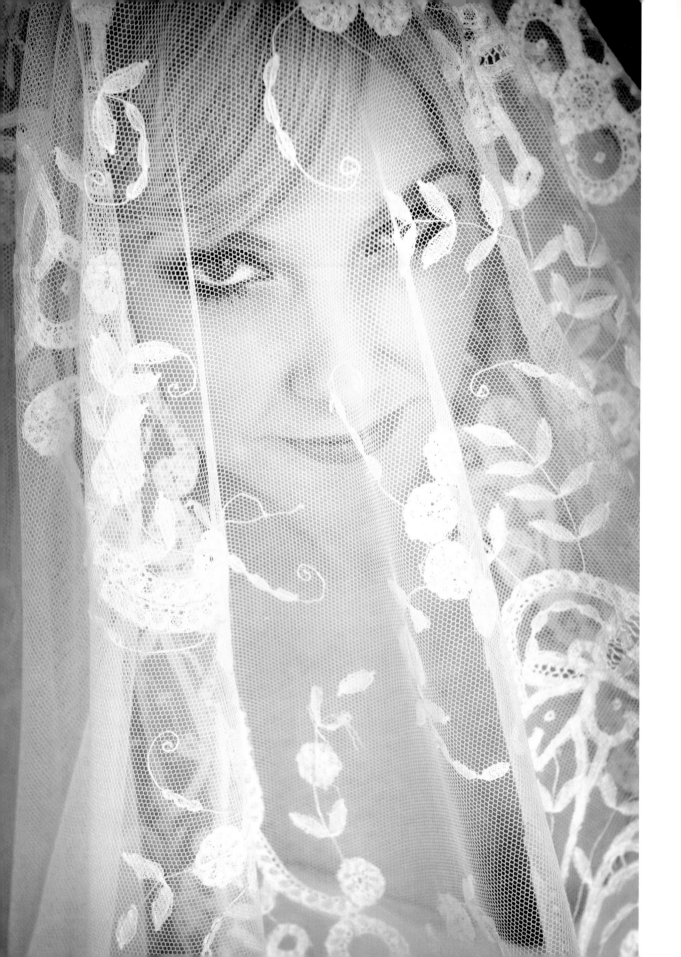

Introduction

At Damon Tucci Photography, I don't presume to say that my approach is the only way to photograph a wedding, just that it has worked for me and my studio for more than twenty-five years. Let's face it: wedding photography is not open-heart surgery, but that doesn't stop someone from suing if you botch one. Do not enter into this profession lightly. The novice photographer should not put himself in the high-pressure situation of photographing a stranger's wedding without the proper training or experience. A smarter approach is to photograph the wedding of a friend who can't afford to hire a pro. In the meantime, you can use this book as a tool to guide you on your path to future success.

Style

Our studio has a distinctive style that comes from our specific approach to wedding photography. We shoot lean and mean using a lot of available light. (When we use flash, we use it in combination with ambient light or off-camera.) We shoot at a very loose depth of field, typically f/1.8 to f/5.6. We strive for a contemporary look but pride ourselves on capturing those critical family shots that Mom always asks for.

Learn from the Masters

I've drawn a lot of inspiration from David LaChappelle, Henri Cartier-Bresson, Herb Ritts, Renaissance painters, and Greek and Roman sculptors.

In Florida, where my studio is located and where we do most of our work, lighting is always a challenge. The natural light is hot and it's always changing. When you're ready for full sun, a cloud drifts overhead. Or it starts to rain. Or you get a mix of the two. It changes often, and it keeps you on your toes. So a fast and flexible system works well.

We've taken knowledge gained from studying other photographers' techniques and applied it to the fast-moving world of wedding photography. We love using available light, simplifying our shooting situations where possible, and seeking out pockets of great light. We've learned that those pockets are everywhere—you just have to train yourself to see them. This is a more involved process than noticing great

FACING PAGE—This beautiful bride's confidence is apparent in her expression. Capturing telling expressions and fleeting moments for the bride and groom to cherish is our goal when photographing weddings.

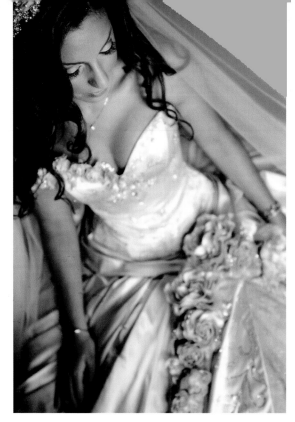

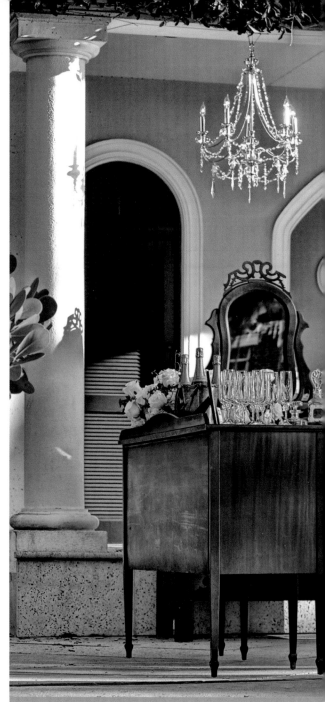

ABOVE AND RIGHT—Surround yourself with great photography, learn from the masters, and challenge yourself to create stand-out images that speak to your clients.

landscapes or aesthetic scenes. It's a mindful process of observing your environment and how the light falls within it.

Set Goals and Get Inspired

Henry David Thoreau said, "In the long run we only hit what we aim at." In other words, it is good to have goals.

At my studio, we surround ourselves with great photography. We are inspired by photographers like David LaChapelle, Yosuf Karsh, Patrick Demarchelier, Richard Avedon, and James Nachtwey, just to name a few. Renaissance painters are great to study, as most of our lighting techniques come from them. They were the masters of turning a two-dimensional medium like a painting into a three-dimensional work of art. Great movies are another place to find wonderful ideas. Their compositions and lighting can be amazing. Personally, I was trained on lighting as a filmmaker, and I believe that it was a huge part of what makes me who I am today. Speaking of art, we can thank Greek

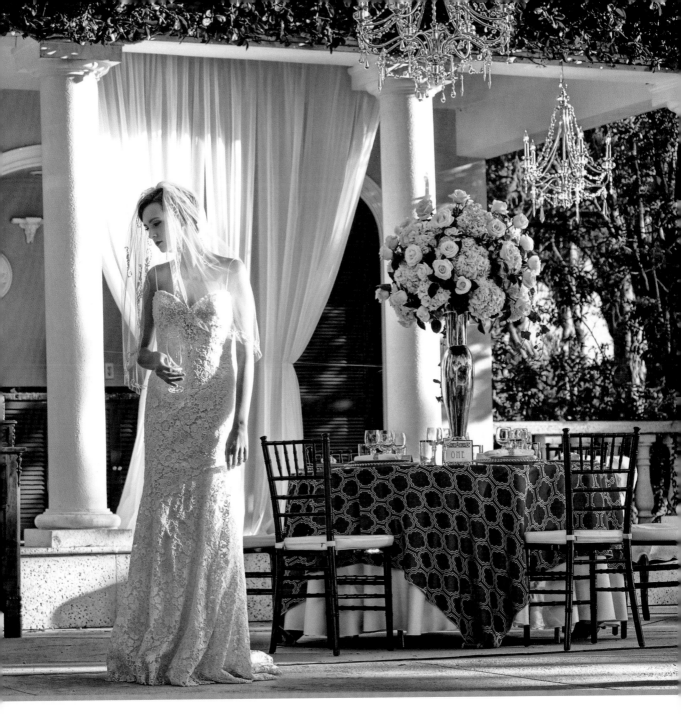

and Roman sculptors for many of the poses that we use today.

Inspiration is all around us. Whether it is in the future or in the past, we just need to tune into it. It is imperative to seek out work that you admire. I don't suggest you copy it, but let it inspire you. Emulate the qualities and characteristics you admire and make them your own. No one can afford to rest on their laurels. Ideally, we will all refine our skills constantly and strive to be better at every aspect of our profession.

1. The Strategy

We have a strategy. There is a method to our madness. Our strategy employs a recipe for success under any circumstances. It has been used during hurricanes, tornadoes, rain storms, and under sunny skies. Being a professional means consistently coming home with the goods—regardless of the circumstances.

Be Proactive

Our photographers do not simply sit like flies on the wall and wait for things to unfold—we are very proactive. We are unobtrusive, but we are not afraid to make things happen. When we photograph a wedding, we try to tell the story of that event so that it can be recorded for posterity. Much like a writer or reporter, we cover the who, what, where, when, and why elements.

Take a Narrative Approach

We approach our photo documentation as if we are creating a photo essay. We take establishing shots everywhere we go: the bride's house, the ceremony site, the reception venue, and everywhere in between. We then look for details. Details, details, details. Visual attention to the details of a wedding will help propel your photography to the next level.

FACING PAGE AND RIGHT—Great light and a good image design combine to result in gorgeous, one-of-a-kind images.

Learn to Anticipate

We also zero in on the key players and look for the emotional moments that unfold during the day. You must train your peripheral vision to see everything around you. You must learn to anticipate what will happen. Some moments are expected, such as the father kissing the bride

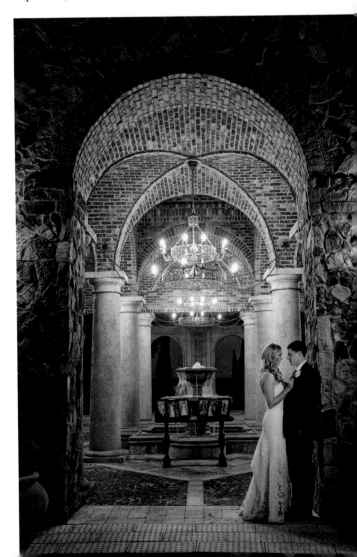

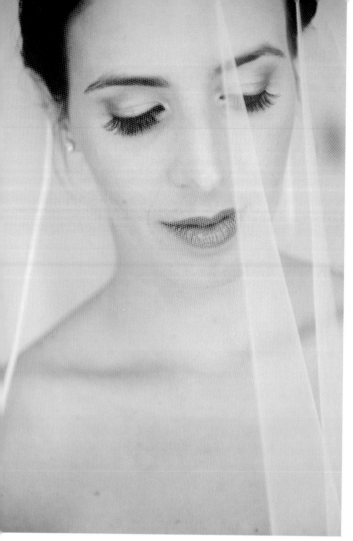

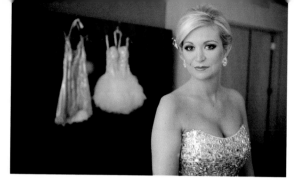

LEFT—A soft, romantic close-up of the bride is a must-have shot, best captured early in the day.

ABOVE—Portraits of the bride made as she prepares for the day are also important to include in the wedding album.

after walking her down the aisle, or a son kissing his mother at the end of the mother–son dance. It's important to continually move around to find the best angle to cover these moments. Don't be rude or obtrusive, but don't be shy either. Get in, get your shot, and get out of the way.

Get the Expected Shots Early

We are determined to tell the unique story of the wedding day. Typically, we try to get all the expected shots out of the way in the first hour and a half, before the wedding has begun. This is when we capture the bride and groom with their parents (usually separately), as well as the bride and groom with their attendants (also done separately). We believe these photos are important, but we shoot them quickly. We also do a quick bridal portrait at this time. Everyone is fresh and energized before the wedding, so it's a good time to capture these portraits while the sense of anticipation is still strong. (We will get into this in more detail later in the book.)

Our plan is to capture as many as possible of the portraits, family shots, and portfolio-type photos in the early hours of the day before the pace picks up. Once the ceremony rolls around, you won't have time to step away to experiment with different photographs. You'll also have less time to pull the wedding party and families away for posed pictures. So get the expected shots out of the way in the beginning. Then you can just have fun and let the day unfold.

During and after the ceremony—when people have shed their nervous energy and are more relaxed—you can capture those real moments that make every wedding day special. (This will be covered in greater detail later in the book.)

2. The Consultation

t my studio, we feel that it is important for photographers to meet with the bride and groom personally. Our sales consultations are usually done either with the bride and groom, the bride and her mother, or just the bride.

Is It a Good Fit?

The consultation is the best time to determine if this is the right client–artist fit. Today's brides are savvy about photography and know buzzwords like "photojournalism" and "documentary style." However, all too often these terms

We try to get all the expected shots out of the way in the first hour and a half.

mean something different to them than they do to us. It's important to communicate effectively and ensure that you and your clients are on the same page. Although today's clients usually don't want hours of posed shots, it has been my experience that they *do* want a standard set of core photos. The key is to make sure that we are speaking the same language and that we are all working toward the same goals.

During the consultation, you can determine whether or not your photographic style suits the tastes of the bride and groom.

Cover the Basics

During the initial meeting, we design a plan for a successful wedding day, outlining realistic expectations and a loose timeline. We ask questions about scheduling—when the ceremony starts, when the reception starts, and what

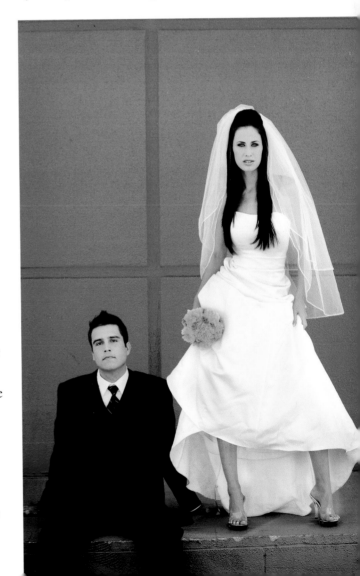

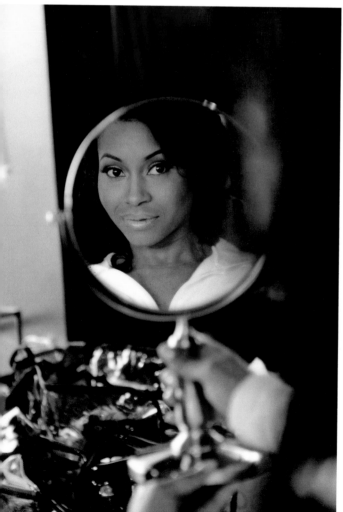

ABOVE AND LEFT—Capture every stage of the wedding as creatively as possible—and be sure to document the many emotions that the bride, groom, and attendants will experience on the special day.

sort of time we will have for photos in between events. We also find out whether or not the couple is working with a coordinator, then establish the ceremony and reception locations. Coordinators can be a tremendous ally in making sure everyone is on time and in the right place. They can make your life easy if you treat them with respect.

Our Approach

Next, we outline our loose approach to the day. For a typical wedding, we start with the bride about ninety minutes before the ceremony. She will either be getting ready at the church, in a hotel, or at home. We ask if it is possible for her

bridesmaids to be completely dressed and ready when we arrive. We also request that the bride's hair and makeup be completed, but that she is not yet in her dress at this time. We like to get a shot of the gown hanging up or lying on a bed because it sets the tone for the beginning of the story of the day. I always work with an assistant or associate photographer, preferably a female, who will have an advantage in photographing the bride while she is putting on her dress.

During the first several minutes that our photographers are on-site, we usually shoot details such as the dress, shoes, and flowers. This takes about fifteen minutes. By then, the bride is often ready to put on her dress. A female associate goes in to capture the initial shots and signals when the bride is fully dressed, and we continue to capture "getting ready" shots (see chapter 4).

The next step is to take all the bridesmaids, the bride, and her parents downstairs or outside—usually to an open-shade area with a nondescript background. In about fifteen minutes, we photograph each bridesmaid individually with the bride, then grab a group shot. We will also photograph the parents separately and then together with the bride. After that, we spend about twenty minutes on the bride alone. We are careful not to stray too far, but you will be amazed what you can get while everything is fresh and pretty before the ceremony.

After the ceremony, the next time crunch involves getting the family shots.

The entire process with the bride's party takes about forty-five minutes to an hour to complete. You will want to have her hidden away roughly thirty minutes before the wedding. Otherwise, the mother of the bride, minister, and coordinator get nervous about the bride being seen too early.

When the guys are getting ready, the moments in between the shots can be priceless.

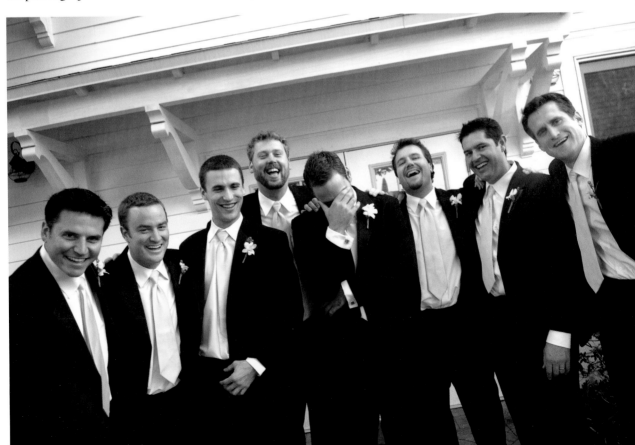

Nobody seems to mind if the groom is walking around in plain view prior to the ceremony, so we photograph him after the bride. Grooms typically only require about fifteen minutes to photograph. We photograph the groom with each groomsman, followed by a group shot. As with the bride, we then photograph the groom's parents separately, and then capture some images of just the groom.

After the money shots of the bride and groom, we head for the reception . . .

Once these principal shots are out of the way, we get ready for the ceremony. Because we work as a two-photographer team, we try to get different perspectives if circumstances and the location permit.

After the ceremony, the next time crunch involves getting the family shots. I suggest capturing all of the main players first. We typically pose the bride and groom, then add the bride's parents, followed by her immediate family and

LEFT AND BELOW—Scouting the reception for interesting backdrops and great lighting before the event can help you to make quick work of getting incredible shots.

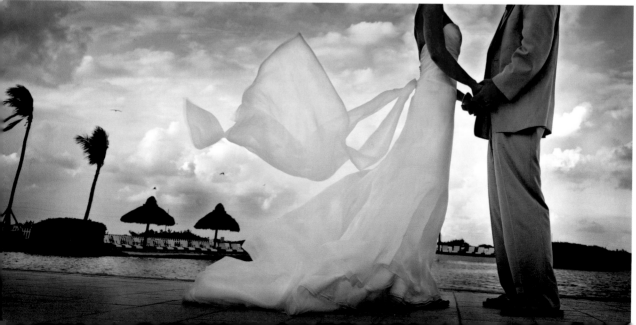

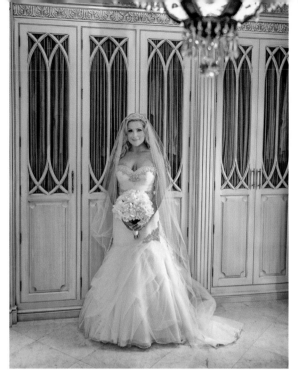

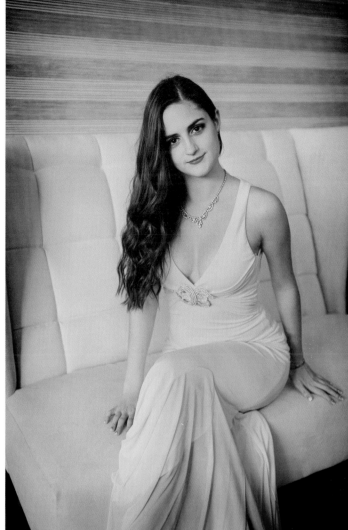

ABOVE, TOP AND BOTTOM RIGHT—Capture the must-have posed shots prior to the reception, before everyone lets their hair down.

grandparents. Next up are the groom's parents, and the same routine follows.

After the family shots, we pose the bridal party, then aim to spend about thirty-five minutes with the bride and groom. Any other group shots (aunts, uncles, friends) that time doesn't allow for can be captured at the reception. This gives us more time with the bride and groom.

After the money shots of the bride and groom (see chapter 7), we head for the reception site and document the room before the couple and guests arrive. Once the guests enter and the happy couple is announced, we simply do our best to document the party.

Using this system, over the course of an eight-hour wedding the bride may only have to pose for about eighty minutes or so, and the groom will be involved in the picture-taking for about forty-five minutes. The rest of the time

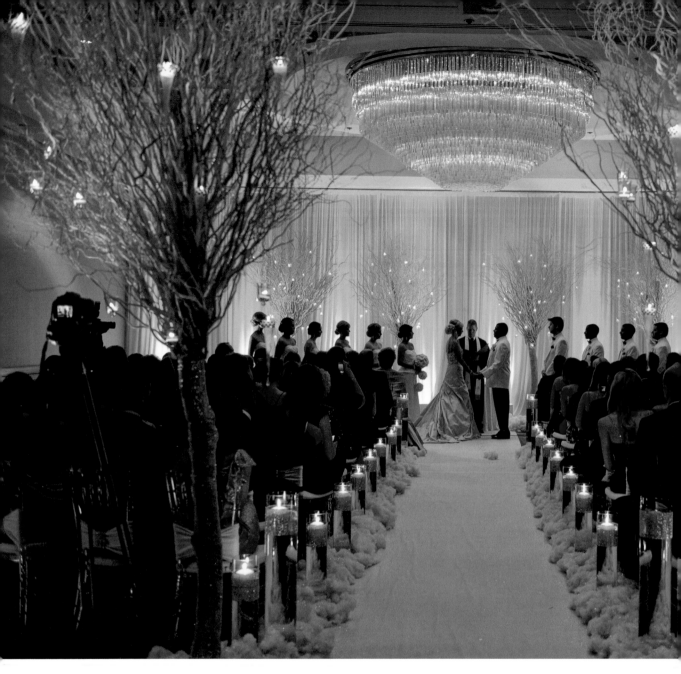

is theirs to have fun. In addition to letting the bride and groom spend more time celebrating with their guests, this approach also lets you hedge your bets—you get all of the expected shots out of the way in the beginning, making sure to get the more traditional family shots that will please the parents and grandparents. Getting the mandatory shots in those early hours also lets you shoot the posed images while people are more reserved and not yet interested in letting their hair down. Later, at the reception, the drinks will be flowing and people will loosen up—and that's when you can look for more "real" moments to capture.

During the initial consultation, we tell our clients that this is our preferred approach—but

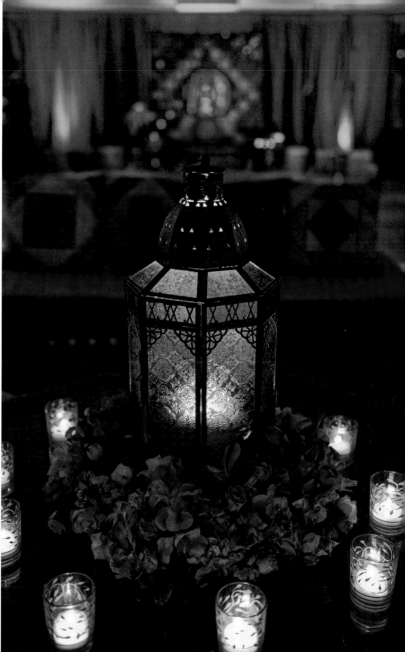

LEFT—When the scene permits, a wide view like this one can make a wonderful establishing shot in the album.

RIGHT—The couple goes to great lengths to ensure that every detail of the wedding is just perfect. Be sure to capture some images that document these details.

if everything goes to hell in a handbasket, we will just document the event journalistically. For example, at one wedding I photographed, a tornado destroyed the reception site an hour before the guests were scheduled to arrive! The show had to go on, though. Luckily, the bride went with the flow and we all ended up having a lot of fun. You can never predict events like this, so it's a good idea to make your clients aware that, sometimes, everything doesn't go exactly as planned.

3. Gathering the Gear

*H*place for everything and everything in its place. This adage sounds like a no-brainer, but many photographers' gear is a mess. During the wedding day, there are a lot of things you can't control. Your gear, however, is not one of those things.

Pack It Yourself

I feel that it is important for a photographer to pack for his or her own shoot. If you let your assistant pack and something is forgotten, it can create tension. Take the time to do it yourself and you'll be happier. Create a checklist and have your assistant confirm everything before you leave. The key is to double and triple check that you have whatever you may need. Even if you get a last-minute call and have to run out the door for the job, having everything organized in advance will make these emergency situations much easier to handle.

Don't Wait Until the Last Minute

Prep your equipment the day before. Make sure all of your batteries are charged and you have enough clean and formatted memory cards for the event. Clean your lenses with a micro-fiber cloth and air spray. Check that your camera sensors are spotless, as well.

Our Kit

A rolling case, such as the Lowepro Pro Roller 1, is an excellent asset. It is generous enough to fit two full systems and will qualify as an airline carry-on. We have memorized where everything

Keeping your gear organized means a little less chaos to deal with on a busy wedding shoot.

An AlienBees monolight and Vagabond Mini portable power system.

goes and use two of these rolling cases—one for cameras and one for lights. I have an AlienBees setup with me.

You need a minimum of two camera bodies for your main shooter. Ideally, the main photographer should have two camera bodies and the associate photographer should have one (we take Nikon D700 and D800 DSLRs). If one body malfunctions, the main shooter can use his backup. This is the system we employ. We also have standby gear that an off-duty associate can bring to us in a pinch. This is a good arrangement if you have a support system, such as nearby family members or other studio employees. Photographers who choose to work alone should always have a main and backup body. The bottom line is that you need to be prepared for anything.

We always make sure our spare equipment is safely locked in our vehicle or in a secure room at the site.

We also pack a range of Nikkor lenses: a 16mm f/2.8 fisheye; 50mm f/1.4; AF micro 55mm f/2.8; 85mm f/1.4; 17–35mm f/2.8; 24–70mm f/2.8; and an 80–200mm f/2.8. However, I recommend that novice wedding photographers keep it simple. Focus on a couple lenses that you know how to use well, then work your way up to a more complete arsenal.

Backup, Backup, Backup

One of the mantras for this book is that, as a professional, you need to come home with the goods every time. There are no excuses and few opportunities to reshoot after an event. So always have backup equipment—even if your reserve camera is a lesser-quality unit. I can't stress this enough: backup, backup your backup, and backup the backup to your backup.

. . . But Don't Overload Yourself

While it's important to have adequate backup equipment, don't overload yourself while you're out shooting. Having too much gear can distract you from what is going on right in front of you. We prefer to stay lean and mean, so we bring what we need for each part of the wedding. We want to be observers capturing moments, not fiddling with lenses while the moment comes and goes. I like to use one camera (on a BlackRapid strap) at a time. Some photographers like to carry two camera bodies with different lenses, but I find that shooting with two can be cumbersome, and the cameras tend to bump into each other. Plus, it can be a real drag on your neck. In our system, the associate holds a ShootSac and tripod while the main shooter creates great images. The two-camera system does have some advantages as well; it's all just personal preference.

Secure Your Gear

We always make sure our spare equipment is safely locked in our vehicle or in a secure room at the event site. For example, when we go in to photograph the bride getting ready, we usually bring a tripod, reflector, and two cameras—a Nikon D700 and a D800. In a small, over-the-shoulder camera bag, we also pack four lenses: a 17–35mm f/2.8; a 24–70mm f/2.8; a 16mm f/2.8 fisheye; and an 80–200mm f/2.8. Everything else stays locked up.

4. Getting Ready

We like to get most of the expected shots out of the way in the first hour. We usually start an hour and a half before the ceremony and capture the getting-ready shots at the beginning of our shoot. We will start wherever the bride is dressing for the wedding.

Our first capture is often an establishing shot of the scene—then we move in to work with the bridal party.

What to Shoot

We usually have one camera body, a tripod, a fisheye lens, 50mm f/1.4, 24–70mm f/2.8, and 80–200mm f/2.8 lenses, and a flash. If the clients have listened to our suggestions from the consultation, the dress will be displayed and everyone will be ready for pictures. We will document the dress, shoes, and anything special in the room. We are also on the lookout for special notes, cards, or presents from the groom. A lot of times, these gifts will be delivered while you are in the room, and it's great to add them to the other detail shots.

We like to get most of the expected shots out of the way in the first hour.

Set the Stage for Success

Wedding photography is not just about photography. You need to know how to act appropriately. It is almost part show, part photography. During the pre-ceremony time, you will be

LEFT AND FACING PAGE—A photograph of the dress or a shot that shows the bride's final preparations makes a good starting point for a storytelling album that captures the magical moments of the day.

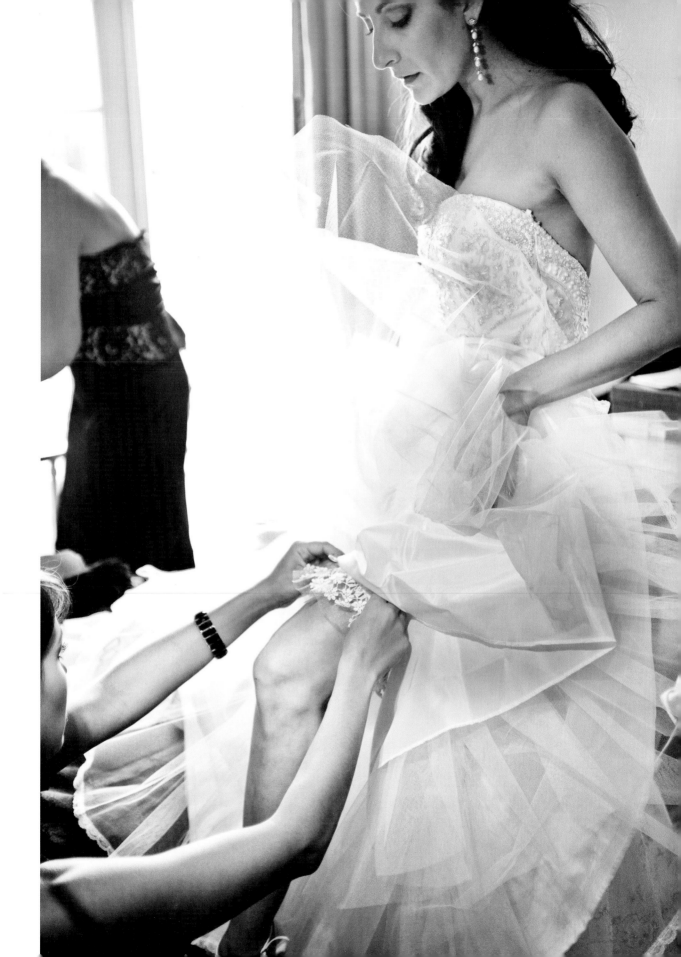

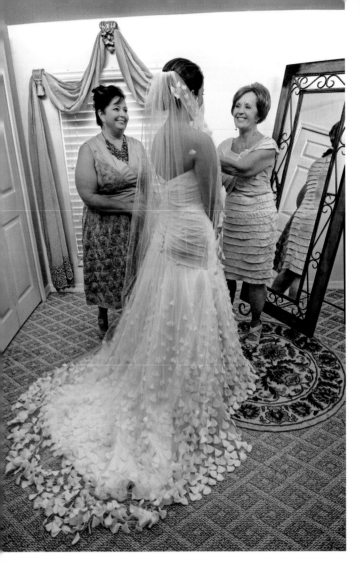

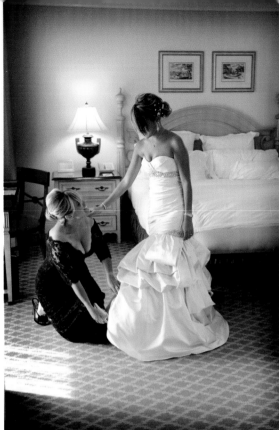

LEFT AND ABOVE—Only those attendees who are closest to the bride will be invited to attend to her as she prepares for the ceremony. Be sure to document the women's meaningful relationships as you capture shots of the preparations.

PRO TIP

When things get challenging, it's a great time to employ a more journalistic style of coverage, ensuring appropriate documentation of the important people, places, and things.

spending a lot of time with the bridal party, and your interaction can affect the tone of the day. To set the right mood, we are very patient. We have a wish list of certain shots we would like to achieve, but we do not like to rush people.

It is best to be low key at this point in the wedding day. We like a fly-on-the-wall approach that allows us to tune in to the climate of the day. If you watch and listen carefully, you will quickly determine who the main players are— and you might pick up on any hot buttons of the day. It always helps to know if there are family members who don't get along, certain people who don't want to be photographed together, or particular guests who must be given special attention. Also, our studio believes in calling people by their first names. During these early moments of the day, we memorize the names of the members of the bridal party as

well as those of the close family members who are present.

If you encounter a particularly emotional bride who isn't feeling cooperative, go with the flow. Try to tactfully and gently keep her on track, but don't force things. Do your best to work around her. Get images of the bridesmaids and the details. Give her some time to pull it together. When it is necessary to involve her in the photographs, mention that it would be a good time to get the dress on or that it would be great to get a few shots of her with the bridesmaids before the ceremony. If she declines, it was her decision. Do your best to make it up later in the day, but also tactfully make those involved aware that they are partnering with you to get great photographs. If they are unwilling to participate, make sure you've given them the option—just in case they get angry later on that you didn't capture certain images. You want to accommodate your clients as much as possible, but you can't force things. Just remember: this is their special day, not yours.

The Bride Getting Dressed

Once you have familiarized yourself with everyone and caught up on the juicy gossip, it is time for the bride to get dressed. Our studio usually has a female associate who photographs the bride at this time. The associate tries to get tasteful yet sexy shots of the dressing process. Female photographers have an advantage during these moments because their presence is less awkward for the bride—she may even try to pose for a shot or two.

Once the bride is mostly dressed, I enter and resume the documentation process as the main photographer. This is typically when the mom or maid of honor is buttoning or lacing up the back of the bride's dress. This is also a good time to photograph the mom or maid of honor helping the bride put on her shoes, garter, jewelry, and other accessories. Look for real emotions, especially between mother and daughter.

The next thing we like to do is capture a couple shots of the bride. First, we do an available-light headshot. Next, we shoot a full-length portrait from the back and perhaps a mirror shot. Capturing these images now, inside a climate-controlled room, ensures that the bride, her dress, her hair, and her flowers are as fresh as possible. This session is an excellent opportunity to capture a few portfolio pieces.

Take the opportunity to photograph the mom or maid of honor helping the bride put on her shoes, garter, jewelry, and other accessories.

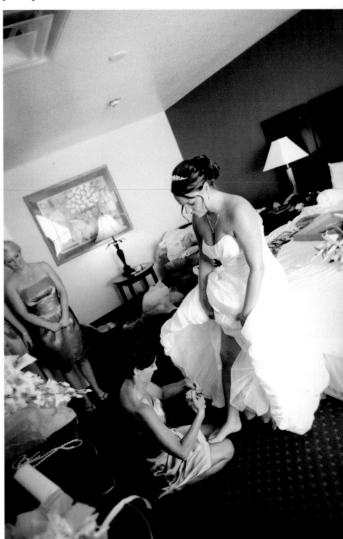

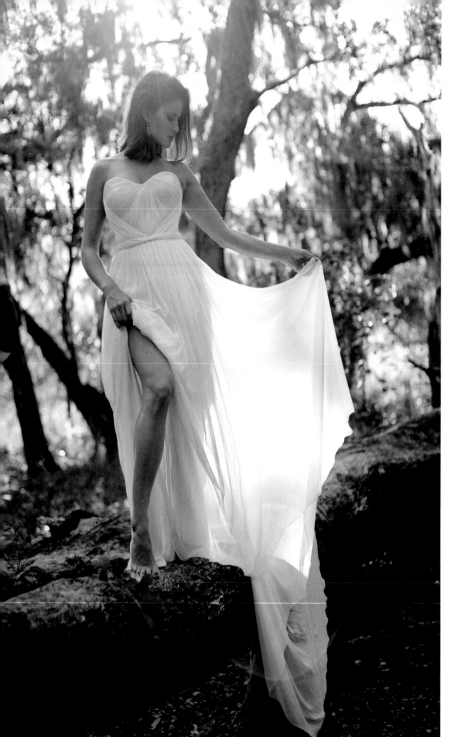

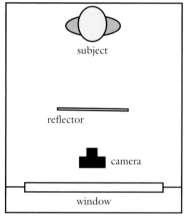

subject

reflector

camera

window

LEFT—Soft lighting and a simple elegance in the posing combine to create a uniquely memorable image for this bride.

ABOVE—This bride was photographed under an overhang at her front door.

Posed Images of the Women

After the session with the bride, we take the bride, bridesmaids, and the bride's parents down to an open-shade location with a neutral background. We have coordinated this with the groom so he won't be walking around and run into us. We quickly photograph each bridesmaid with the bride. Then we take a group shot of the bridesmaids and the bride. Finally, we photograph the mom with the bride, dad with the bride, and then all three together.

Next, we spend fifteen to twenty minutes doing a mini photo shoot of the bride alone. We try to incorporate the flavor of the wedding location into a contemporary portrait. We don't get too crazy because we don't want the bride to get sweaty or flustered. We are mindful not to get her dress dirty and usually ask the maid of honor to help with the train. We carry a bedsheet to lay down under the dress. If you don't have a sheet, you can usually score some towels, tablecloths, or sheets from the venue—especially if you're at a hotel or the bride's home.

We are mindful not to get her dress dirty and usually ask the maid of honor to help with the train.

The pre-ceremony session takes about an hour. About thirty minutes before the ceremony, you should have the bride back in her holding room. Mothers, priests, coordinators, and guests sometimes get bent out of shape if people see the bride before the wedding. We go with the flow and respect their wishes.

In a few instances (usually evening ceremonies where a lack of available light after the event will prohibit shooting), the bride and groom may opt to see each other before the event. When this is the case, you can get most of the posed shots out of the way early. In this case, we usually stage a special meeting where the bride and groom see each other for the first time in their wedding attire. There are two of us shooting simultaneously, and we capture the individual as well as overall emotional reactions. In the days of film, photographers often pushed for this. Nowadays, we let the bride and groom decide—and we only suggest this option when it is in their best interests in terms of the lighting. In our experience, this happens less than 10 percent of the time.

The bride and bridesmaids were posed for this fisheye image before the ceremony, getting one of the expected posed shots out of the way.

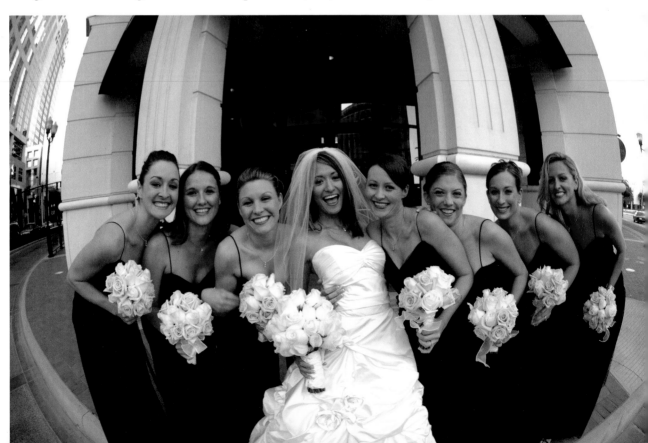

Portraits of the Guys

Now it's time for the guys! We typically meet the guys at the ceremony site thirty minutes prior to the wedding. We do not usually photograph them getting dressed; that only happens at a celebrity or high-profile wedding when we use a team of four photographers. Normally, we will shoot each groomsman with the groom and then grab a shot of all the groomsmen together with the groom. Be mindful that you must photograph the ushers first because they will need to start performing their duties as soon as guests begin arriving. When we're done with the groomsmen, we photograph the groom with his mother, the groom with his father, and then all three together. Next, we will shoot a few pictures of the groom on his own. All of these photos are done in about fifteen minutes.

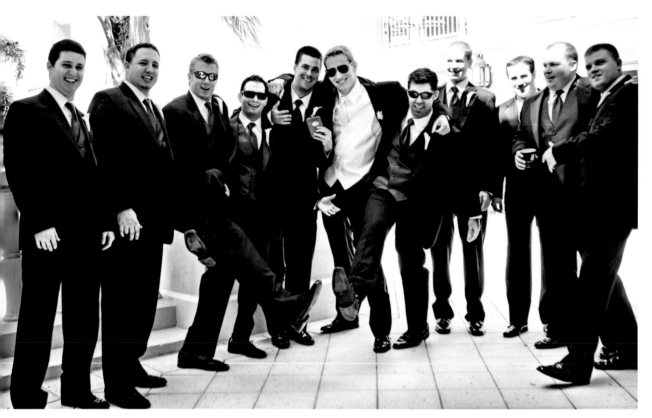

TOP AND BOTTOM—Have a little fun when photographing the grooms-men. Keeping things light will help your subjects relax in front of the camera, which will result in some great photo opportunities.

FACING PAGE—Posing eight musta-chioed men was made easier using this picturesque staircase, which provided a simple way to stagger the subjects' heights to ensure all faces are visible.

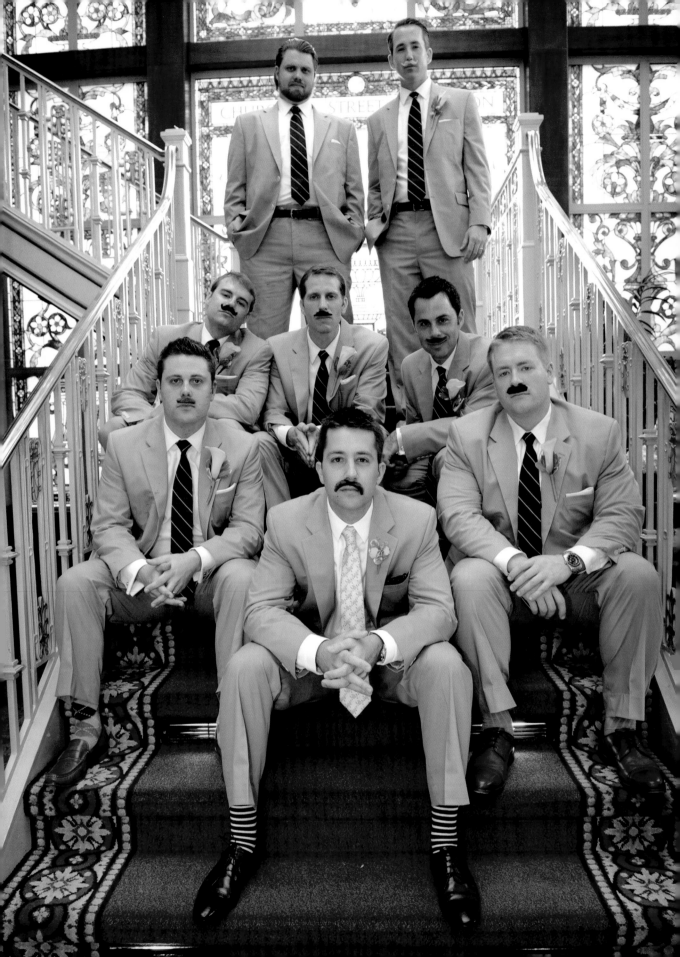

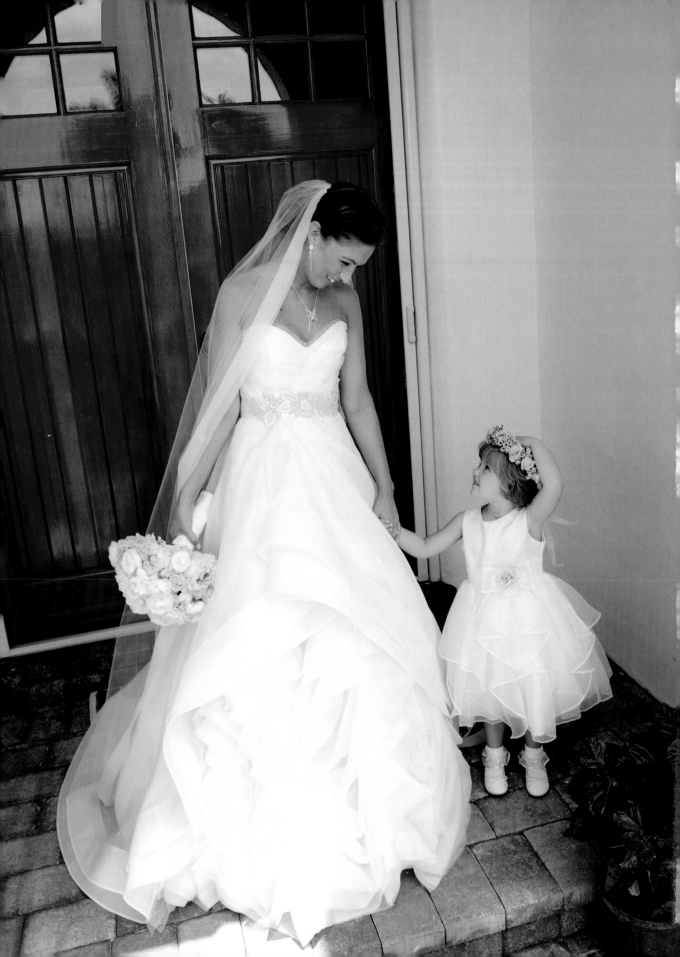

5. The Ceremony

The ceremony is the culmination of months of planning for the happy couple. It is a sacred experience. Brides and grooms are often in a trance-like state during their wedding ceremonies, and the whole event can go by for them in a blur. Your photos, capturing each special moment, will be an everlasting reminder of what really happened—all the little details they may have missed in the flurry of activities and emotions.

Respect the Venue's Rules

It is important for the photographer to know how to act appropriately. Some venues are stricter than others. For example, at many outdoor venues you have carte-blanche freedom to roam around. Inside churches or temples, however,

Your photos, capturing each special moment, will be an everlasting reminder of what really happened . . .

you are usually more restricted. Even when given total freedom, be respectful of the event. Do not linger in front of the parents or the guests. Get in, get your shot, and get out. Even though this may be your tenth, hundredth, or even

thousandth ceremony, chances are it's a first for the bride and groom, so try to be as unobtrusive as possible.

In a church or temple wedding, you must first meet and befriend the ceremony site's liaison. Most churches and temples have specific rules about what a photographer is allowed to do. If you introduce yourself and acknowledge these rules, you will usually put them at ease.

FACING PAGE—Authentic moments add warmth in the album and evoke an emotional response from viewers.

RIGHT—This image captures a ceremony detail and an establishing shot in one frame.

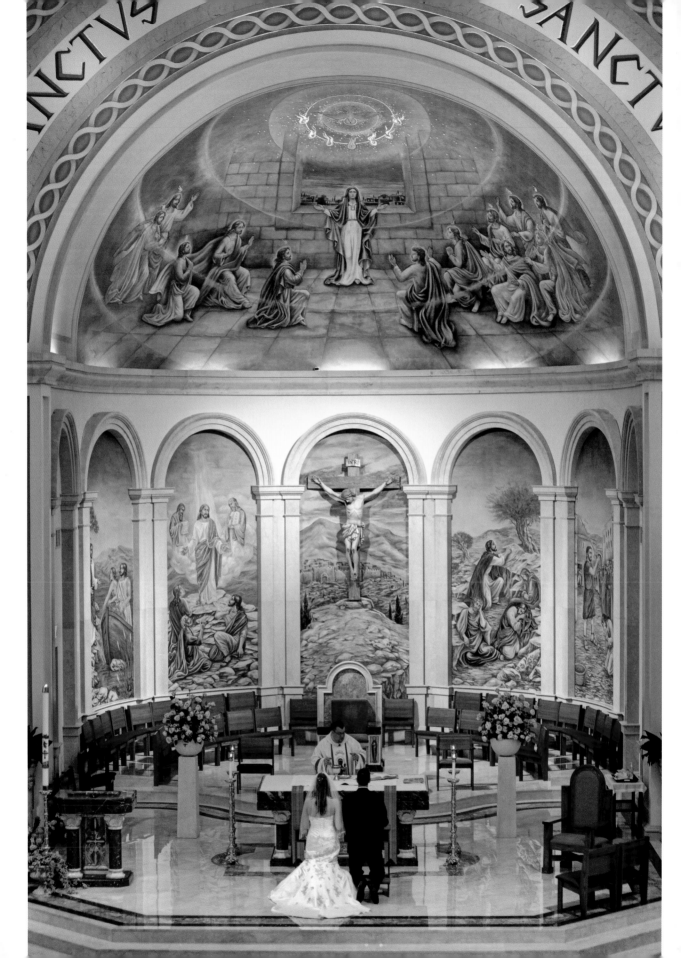

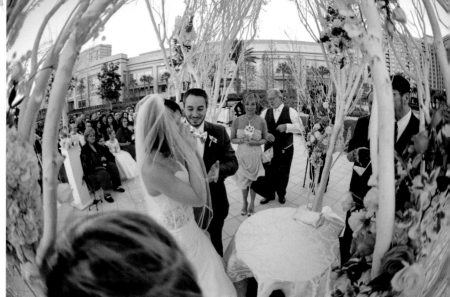

FACING PAGE, ABOVE LEFT AND RIGHT—Make sure that you and your assistant shooter are well versed in the rules governing shooting during the ceremony.

If you do not, they will have a watchful eye on you and they can make your life difficult. Keep in mind that these officials are just doing their job and trying to preserve the sanctity of the experience. If you develop a good relationship, they will remember you and often give you more leeway the next time you shoot there. Conversely, if you ignore their rules, your next shoot will be a living hell. Some venues have even blackballed vendors for inappropriate acts, and it is not uncommon for the celebrant to stop in the middle of the ceremony and chastise the out-of-bounds photographer. *(Note:* After the wedding, it never hurts to follow up with the ceremony-site liaison and offer some prints or a DVD or thumb drive of images of their venue. That will buy you preferential treatment the next time you photograph there.)

All places of worship differ slightly in their strictness and rules. Many venues post their rules on their websites. Typically, the rules are as follows:

- Photographers are allowed to use flash during the processional and recessional only.
- Photographers may shoot from the back third or behind the last row of seated guests from the middle aisle.
- Photographers are expected to shoot the processional and then move out of the aisle into the pew.
- During the ceremony, photographers must stay behind the last row of guests and may not use flash.
- Photographers can expect to share space and work courteously with the videographer.
- Sites with balconies sometimes restrict the photographers to shooting only from the balcony.

These are the most common rules at ceremony sites, but you never know what you will encounter. There is a church in central Florida where they shut the doors and you must photograph the ceremony through a porthole in the door! The videographer, however, is allowed inside. Go figure.

When we shoot an event at a church, we ask ahead of time if one of our photographers

can set up to the side of the altar with a tripod. At 1600 ISO, we can shoot at f/2.8 and $^1/_{100}$ second these days. However, churches don't like a lot of movement, so it puts them at ease if you tell them you will be stationary and working on a tripod. We can capture nice shots of the reactions of the bride, groom, parents, and wedding party during the ceremony. The photographer at the back of the church will then do most of the documentation of the event itself.

Another trick is to plant one of your staff as a guest in the front row with the parents. To pull this off, you definitely need the parents and clients to be on board. The planted photographer will only be able to shoot a few poignant moments before putting the camera away. If they are snapping away throughout the ceremony, the celebrant will tell them to knock it off. Save this trick for huge events and be courteous if you employ it.

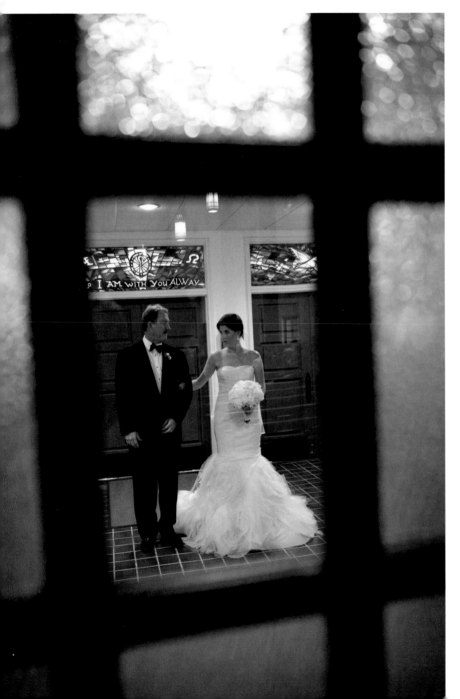

Another trick is to plant one of your staff as a guest in the front row with the parents.

LEFT—An image of the bride and her father as they enter the ceremony venue is a must-have shot. Be sure that you're in a good position to capture it.

FACING PAGE—In some locations, photographers are required to shoot from the balcony.

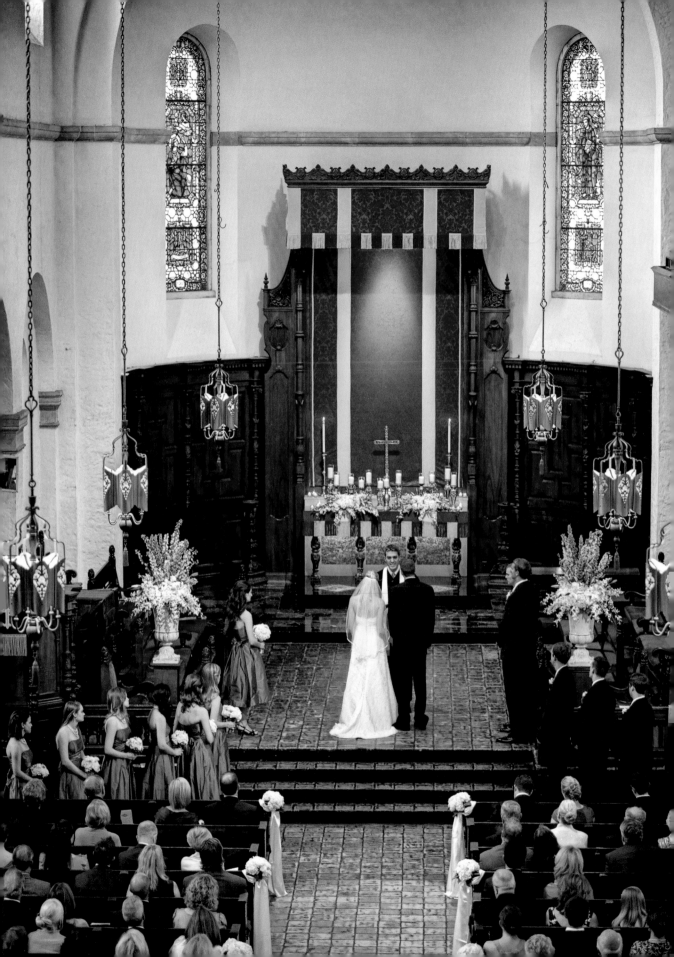

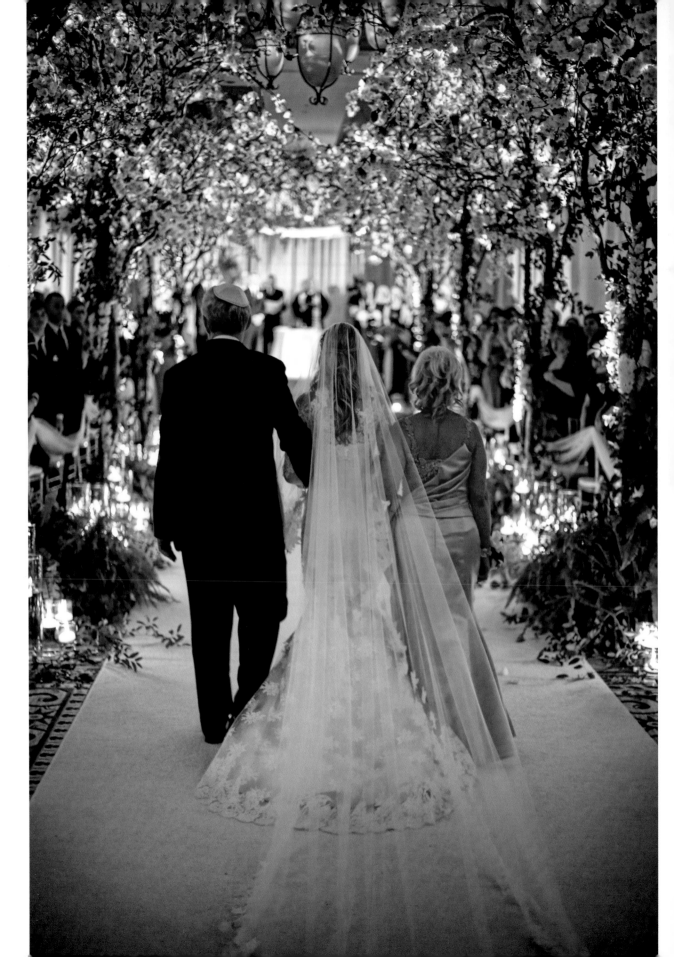

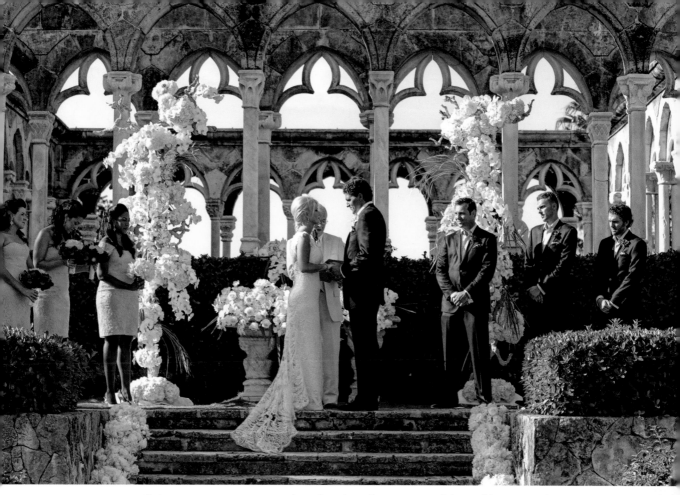

FACING PAGE AND ABOVE—Strive to get some ceremony shots that show the parents and the wedding party. They are typically the people the bride and groom most cherish.

Two Photographers

Typically, our studio has two photographers covering the ceremony. One will capture the processional and images from inside the sanctuary. The other will hang out with the bride

The second shooter will capture the bride's entrance from the back as she walks down the aisle.

during those nervous last moments. The second shooter will also try to capture the bride's entrance from the back as she walks down the

aisle. Once the ceremony begins, both photographers stay in one place with their tripods. As noted above, ideally this entails having one photographer to the side of the altar and another at the back of the church.

Exposure

We often shoot ceremonies with 80–200mm lenses. We set our ISO between 800 and 1600 and shoot with exposures anywhere from f/2.8 at $^1/_{20}$ second to f/2.8 at $^1/_{100}$ second. Most of the churches and temples we encounter have lighting that lets us work at f/2.8, $^1/_{100}$ second, and 1600 ISO. *(Note:* Our Nikons allow us to

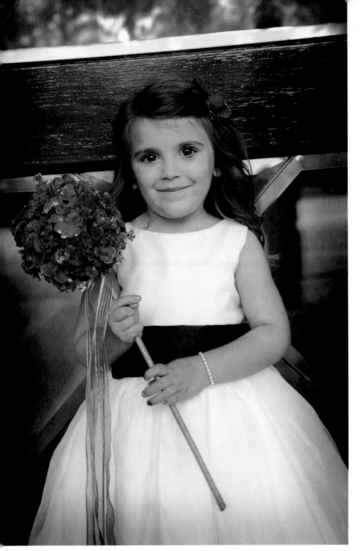

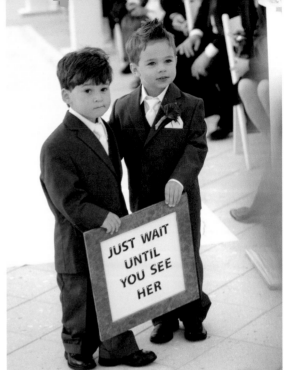

LEFT AND ABOVE—Working with a second shooter will allow you to get multiple perspectives on the events as the ceremony unfolds.

FACING PAGE—Be on the lookout for emotional moments between the bride and groom. These shots are sure to elicit a big reaction—and that will translate into big sales.

shoot at ISOs up to 6400. The 1600 setting provides really nice results; 3200 and 6400 are noisier. Still, we usually try to shoot at as low an ISO as we can. This is generally still around 800–1600, but it's nice to know that the camera can effectively shoot at higher settings and still provide a professional-quality image.)

Even though we are prohibited from using flash during the ceremony, we do not mind because on-camera flash tends to wash out and flatten the available light. We prefer to shoot wide open and select the fastest shutter speed we can get away with. The depth of field is not really an issue, but focus is critical; you must zero in exactly on your subject. If you must shoot as low as $1/20$ second, be advised that only about one in five shots will be usable (we rarely need to shoot at such a slow speed now that technology allows us to use a higher ISO). Of course, shooting from a tripod will help to ensure sharp focus. You can also achieve an above-average number of usable images by waiting until your subjects are not moving and then doing a burst of about three exposures.

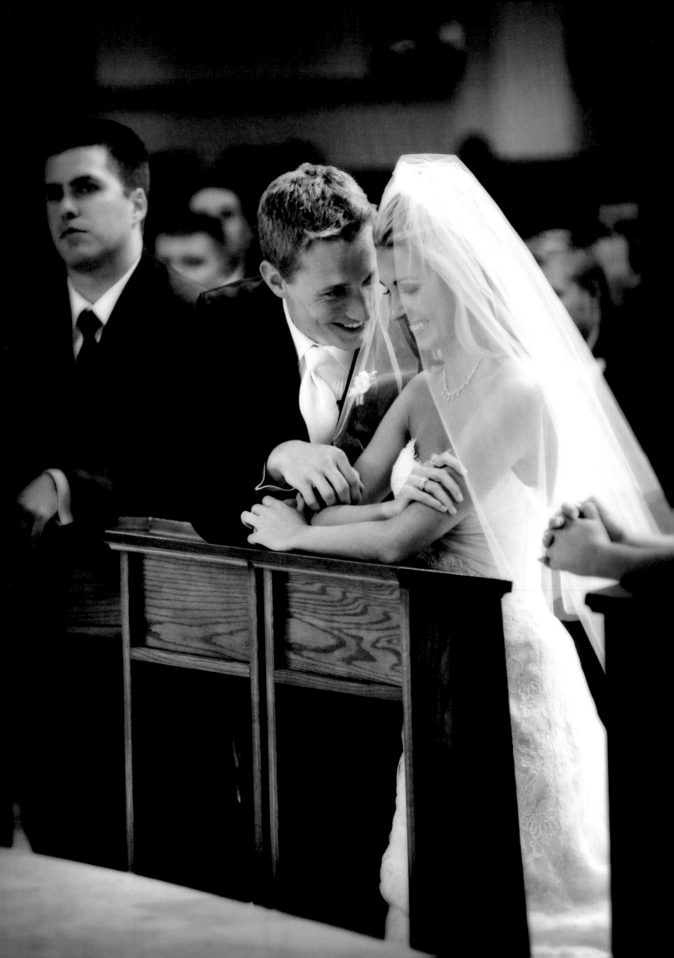

White Balance

Our photographers determine the proper white balance for the ceremony location when they arrive at the scene. With the advent of Adobe Lightroom and RAW files, it's a simple task to make mass color corrections in postproduction.

Once we have selected the proper white balance, we document the ceremony as we would any other story. We start with some wide-angle establishing shots, then get some medium shots, and then telephoto images.

BELOW, TOP AND BOTTOM RIGHT—A cermony tends to last about thirty minutes, on average. This gives you plenty of time to watch for and capture beautiful expressions, meaningful actions, and the mood of the ceremony.

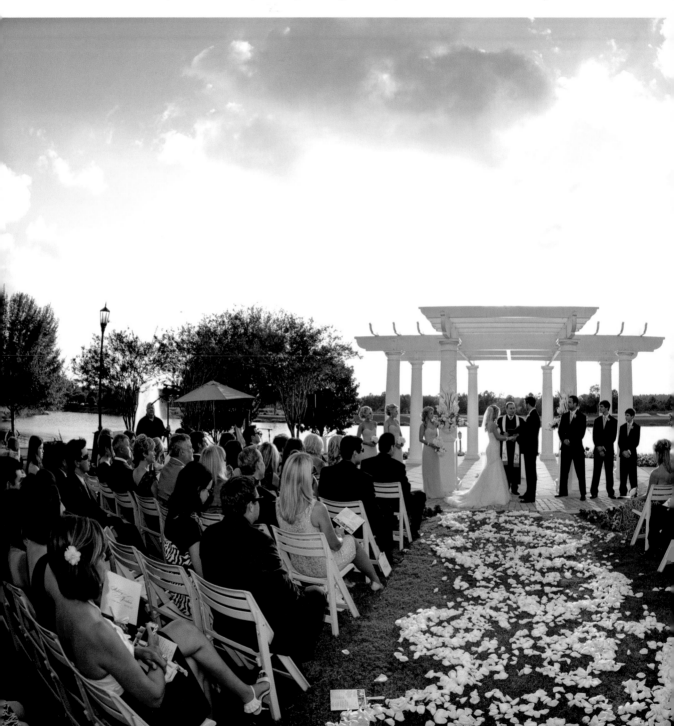

Watch for Key Moments

Most ceremonies last fifteen to sixty minutes, with the average being about thirty minutes. This is ample time to get the shots you need. This is one time during the day when you are not rushed, so take your time and immerse yourself in the ceremony. Carefully observe your subjects for expressions worth documenting.

At the beginning of the ceremony, the first thing the shooter at the front of the church/site should look out for is when the celebrant asks, "Who gives this woman to this man?" or something similar. The father will reply, "Her mother and I do." Then he will usually give her a kiss on the cheek. This is an event worth capturing. Be ready.

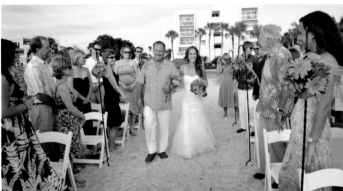

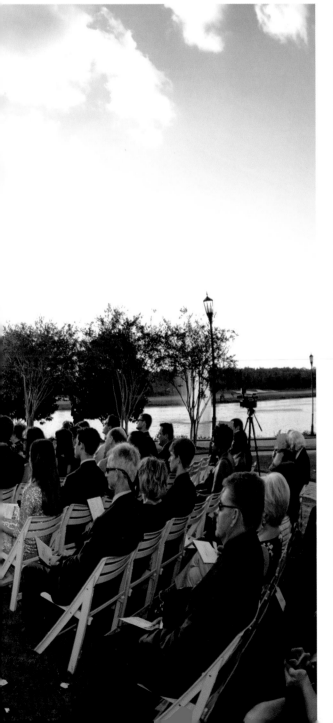

Eight hundred people were in attendance for this couple's Indian wedding.

The photographer who is positioned at the rear of the church is responsible for the overall shots, but he or she also has the best angle from which to capture some parts of the ceremony. The ring exchange, communion, lighting of the unity candle, and the first kiss are usually best photographed from this position, so anticipate these moments and be ready for these events.

Understand the Traditions

Most of the ceremony specifics we've discussed so far revolve around traditional Christian weddings. However, it's important not to ignore other religious traditions—particularly Jewish and Hindu ceremonies. These are huge markets, and it would behoove any wedding photographer who wants to make a living to embrace them.

The savvy photographer will proactively learn these traditions and position themselves for success.

It has been our experience that the young people in these cultures yearn for a more contemporary style of photography. Because of this, they often look beyond the traditional vendors of their culture. Many couples would rather have a more modern style and teach you their traditions than be stuck with someone who knows their traditions intimately but whose style of documenting them may not be contemporary. The savvy photographer will proactively learn these traditions and position themselves for success.

Hindu ceremonies are very beautiful, spectacular events. The colors are vibrant, and it is a pleasant departure to be able to photograph something other than white dresses and black tuxedos. The people are gracious and festive, and the guest lists can swell to more than five hundred. Many of the Indian weddings we have

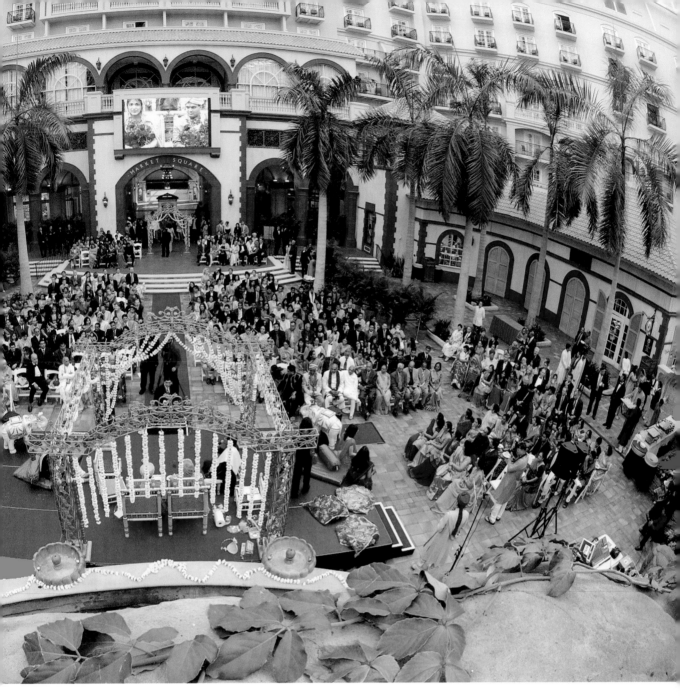

covered have involved three different events: the Garba, the Mendhi, and the actual wedding ceremony. These events may span several days. They are very rewarding photographically, but they are a lot of work. So, when asked to provide a quote for an Indian wedding, bid accordingly.

If you are unfamiliar with Hindu wedding traditions, do some research before tackling such an event. The client will help you learn some of their traditions during the planning process, but you need to do your homework as well. During the ceremony, the couple will often assign a family member to help guide the

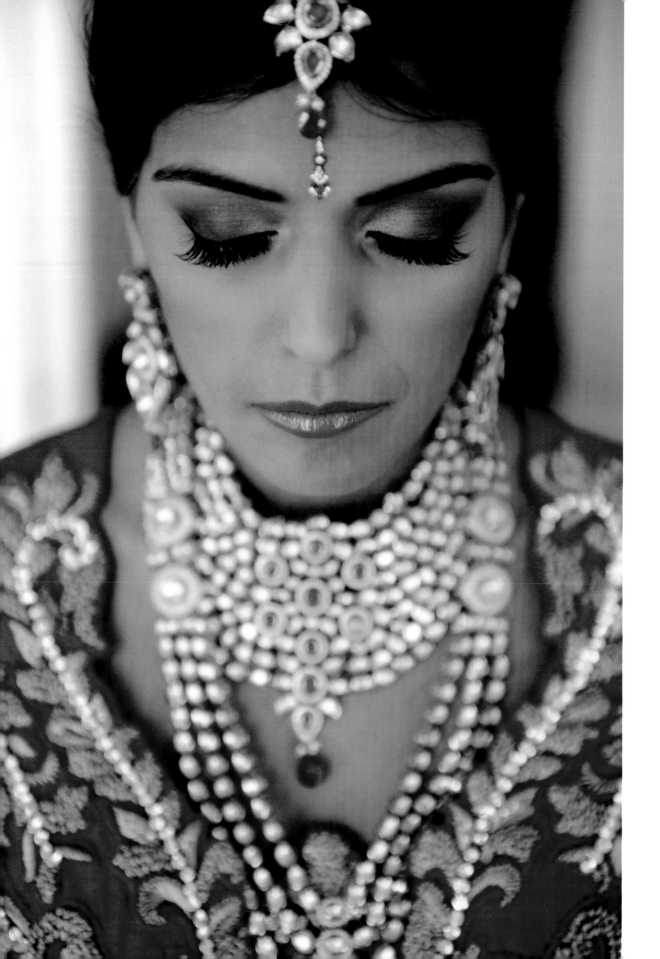

An Indian wedding can span several days. Be sure that you know how much time will be involved before you quote on one of these beautiful, festive weddings.

photographer. These liaisons are a valuable asset, and you should take advantage of their insight to make sure you don't miss anything.

During many Hindu ceremonies, there are few (if any) restrictions placed on the photographer. You generally have full access to position yourself and move around. At some points during the event you may even need to be a little aggressive. For example, photographing the groom's entrance can feel more like shooting a rock concert from the mosh pit than photographing a religious ceremony!

Jewish weddings are also rich with wonderful traditions and require some education to document properly. At Walt Disney World, the Rabbi who performed services at the Pavilion taught me (and the other non-Jewish photographers) the key elements of the Jewish ceremony. While there is much information online pertaining to Jewish weddings, it is my experience that one-on-one counseling is the way to go. If you approach your

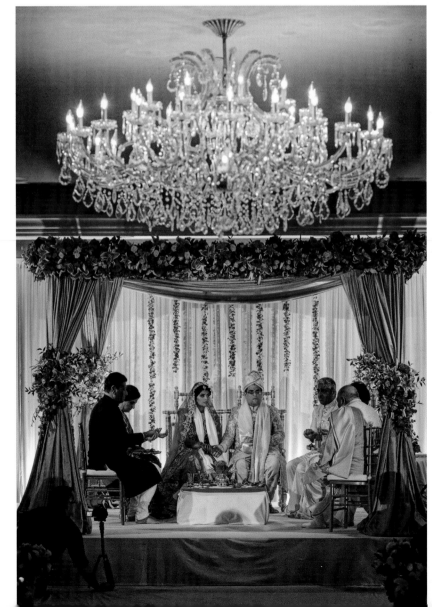

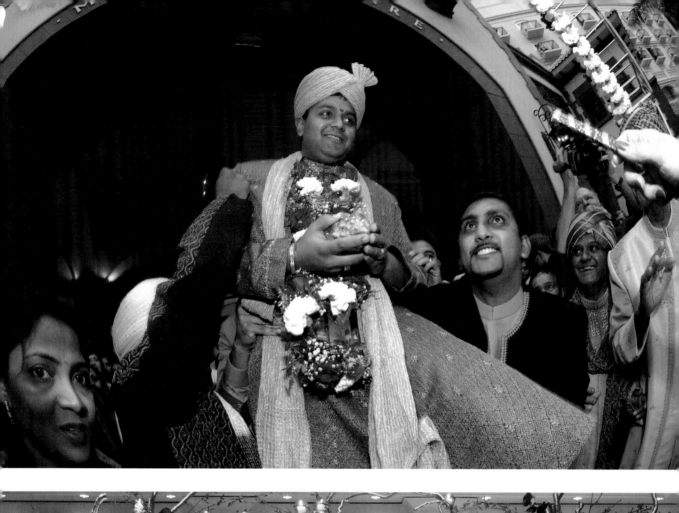

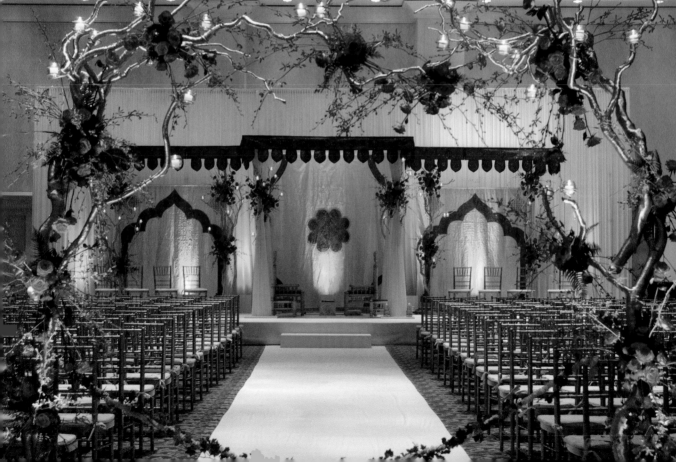

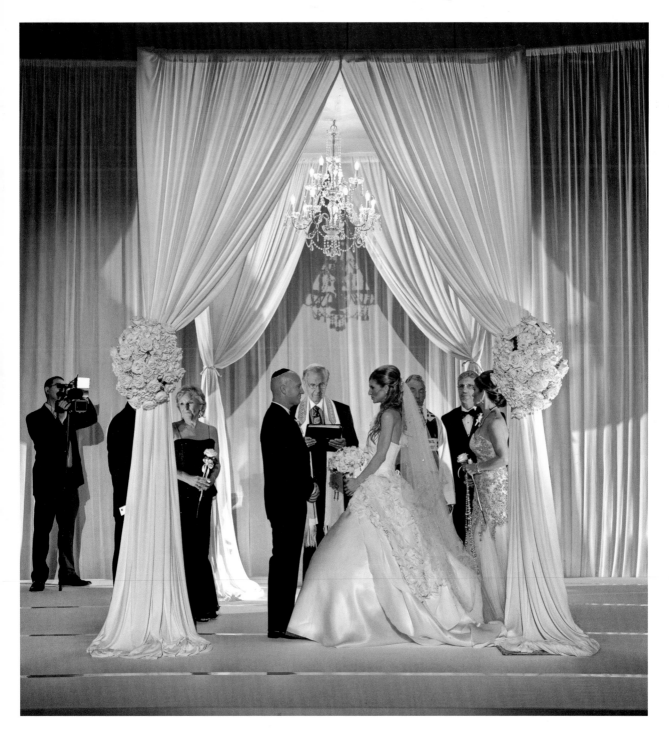

FACING PAGE, TOP—This Hindu groom is accompanied to the venue by his relatives and friends, who arrive dancing and rejoicing.

FACING PAGE, BOTTOM—This location was beautifully decorated for a Hindu wedding.

ABOVE—Jewish weddings are rich with beautiful traditions. If you're new to this kind of ceremony, seek one-on-one counseling to gain insight into the meaningful moments you will be expected to record.

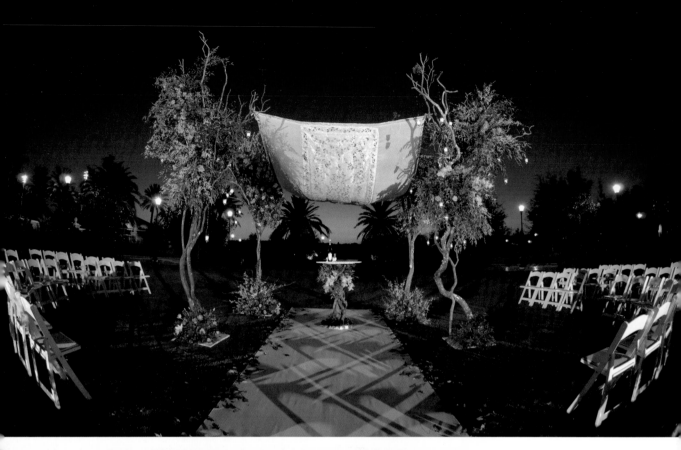

ABOVE—The chuppah, a four-poled canopy, is an important element of most Jewish wedding ceremonies.

LEFT—Jewish weddings are traditionally held after sunset, making for long exposures when shooting outdoors. This image was shot with a fisheye lens, and the camera was mounted on a tripod.

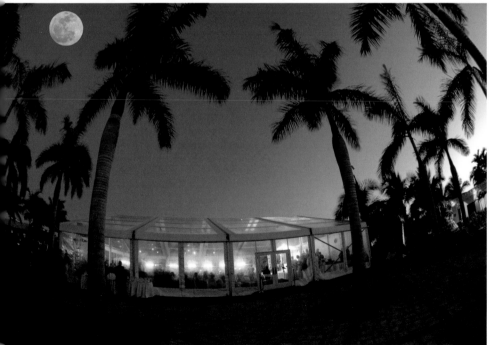

local synagogue, you might find that the Rabbi will be more than happy to educate you about the fine points of the Jewish wedding ritual.

One important challenge for photographers is that the ceremony is not traditionally held until after sundown. This makes for some long exposures at outdoor events.

Two advantages to the outdoor ceremony are free access to position yourself and ample lighting.

Outdoor Ceremonies

Now let's discuss another ceremony type that we frequently have in Central Florida: the outdoor ceremony. Two advantages to the outdoor ceremony are free access to position yourself and ample lighting. Some drawbacks are that they are often only fifteen minutes long and the weather can cause problems. Usually, though, outdoor events can be quite splendid. You just have to work fast.

As with an indoor ceremony, we coordinate our two photographers to capture the entire event from different angles. One photographer sets up in the middle aisle and one works from the back. The major difference is that there is ample light to handhold your shots, so you can move around more freely. Of course, you still do not want to linger in front of the parents or guests. Be as unobtrusive as possible. Constantly look for opportunities, then move in to execute them. Use your freedom of movement to its fullest, capturing all the moments that make the wedding unique.

Beautiful natural light set the scene for the capture of this joyous bride, sharing a moment with the groom. The shallow depth of field keeps the eye on the primary subject's expression.

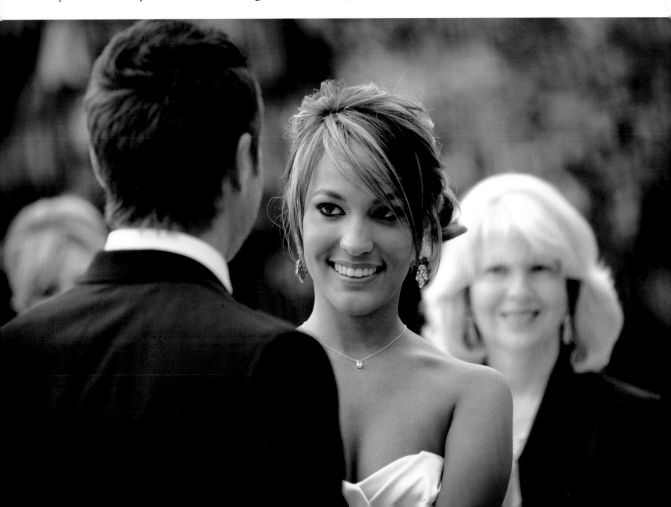

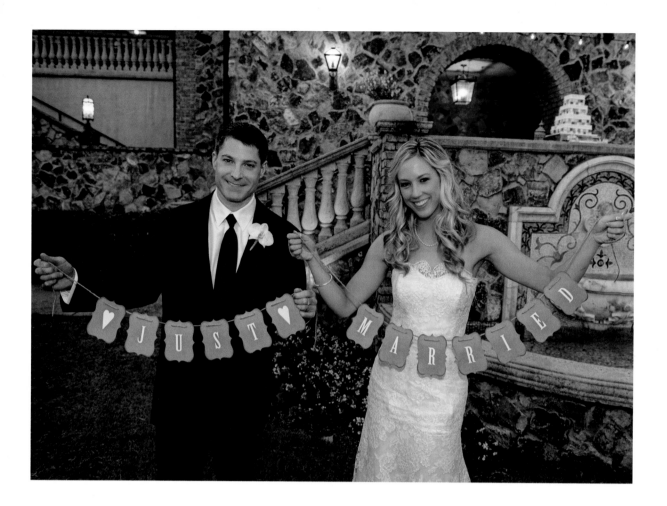

Exposure can be tricky at these outdoor venues—especially if you are working with the sun directly overhead. A good starting point is with the "Sunny 16 Rule." This states that in order to achieve a blue sky in your background, your exposure should be made with the aperture set to f/16 and the shutter speed set to the inverse of your ISO. For instance, if you are shooting at ISO 100, your exposure should be f/16 at $^1/_{100}$ second. This is just a reference, and there are many other factors at work. However, it is a good rule of thumb.

If you are going to incorporate high-speed sync, you should ideally shoot with a larger aperture such as f/2.8 or f/4. For most digital cameras, the flash sync speed is $^1/_{250}$ second, so

ABOVE—A shot of the newlyweds holding a just-married sign is a perfect addition to the wedding album.

FACING PAGE—Beautiful light and an interesting camera angle make this a stand-out shot.

that will limit how wide you can open your aperture. For example, if f/16 at $^1/_{100}$ second is the correct exposure at ISO 100, then a correlating correct exposure would be f/11 at $^1/_{200}$ second. We would typically take this shot at f/8.5 at $^1/_{250}$ second. Sometimes you might even drop your shutter speed down to $^1/_{125}$ second and sacrifice some of the blue in the sky for a better exposure of your subjects.

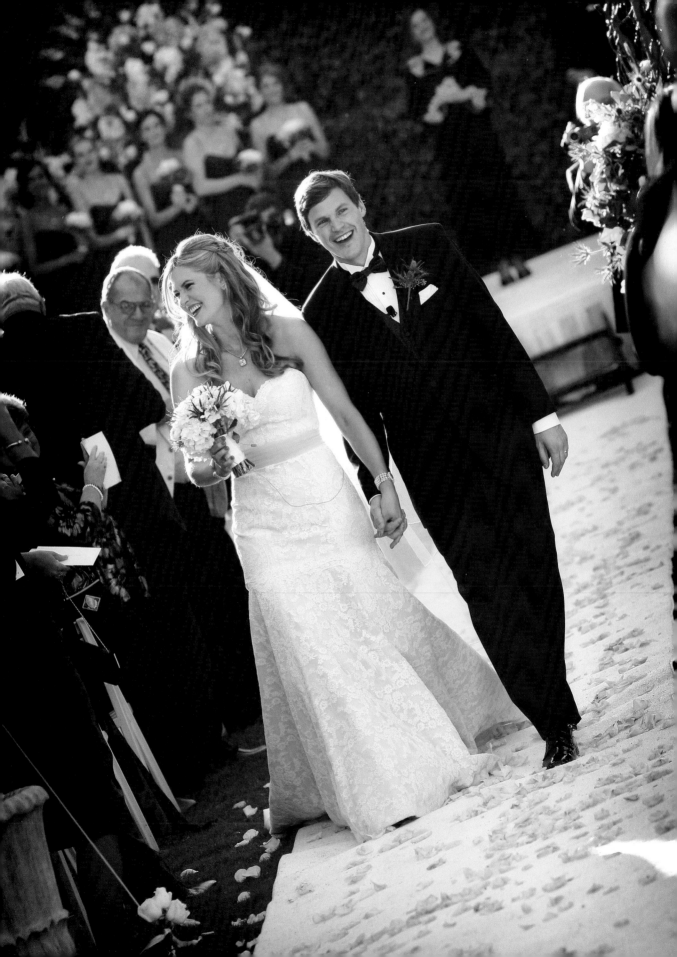

6. Complete Coverage

They may not end up in your portfolio, but every couple wants a few family shots and posed pictures. Our studio feels that family shots are a very important part of the wedding day. In today's world, weddings are often one of the few times that all the family members are together in one place. It is important to document these

Group shots don't have to be stiff. This wedding party wanted to do a jumping shot. It might be a little cheesy, but we think it works.

moments for posterity. However, even though we feel family photos are important, we do not

They may not end up in your portfolio, but every couple wants a few family shots and posed pictures.

want to take all day with them. We would much rather spend time with the couple, creating memorable images of them on their special day. Therefore, we try to steer the couple in this direction during their consultation.

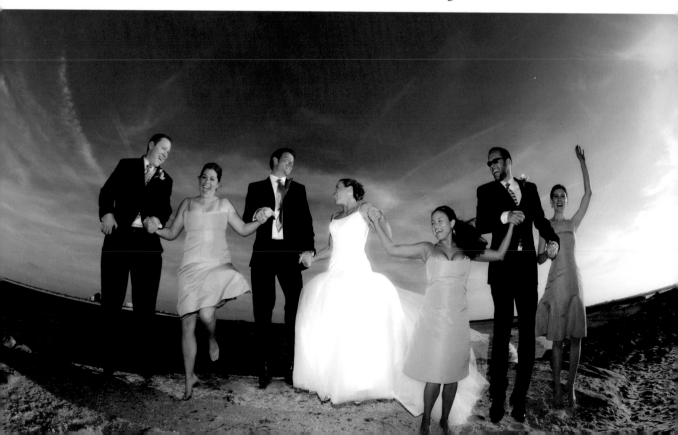

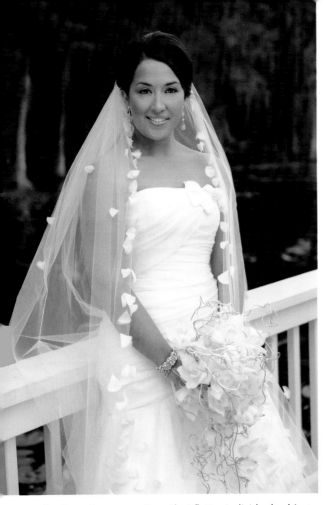

Study posing conventions that flatter individual subjects and groups for the best-possible traditional images.

Be Efficient

After a typical church ceremony, you will have thirty minutes to do photos before the wedding party needs to depart. And here's a little secret: The clock starts ticking when the couple kisses. When your thirty minutes are nearing their end, a mild-mannered church lady will hover over you looking at her watch and back at you. There may be a mass starting shortly, or there may be another wedding (or she may just want to go home).

Here is how we maximize our allotted time: First, we pose the bride and groom in the L position (standing close with their feet at

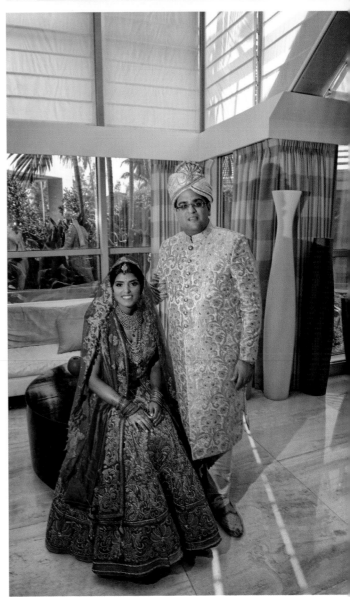

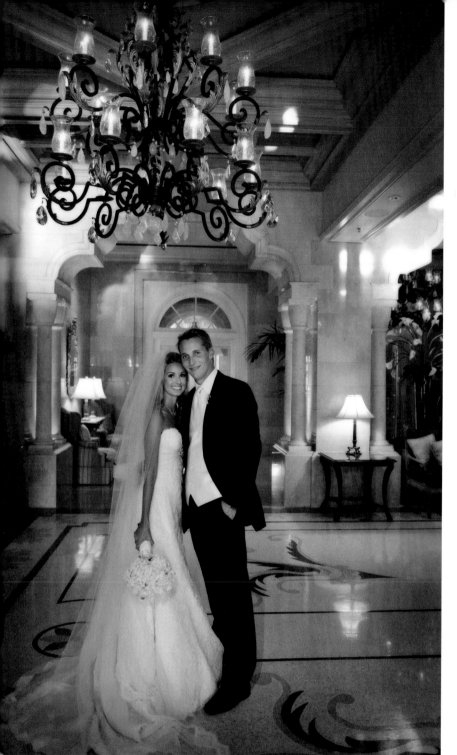

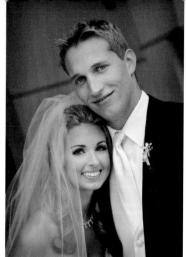

Capture a range of posed shots, from close-ups to full-length, for maximum variety during the sales process.

usually under a time constraint and ready to change out of their ceremonial clothing, so it makes sense to do this image right away.

Next, we work with the bride's parents, immediate family, and grandparents. If there are multiple sets of parents, we try to call everyone by their first name. We also try to work quickly to avoid any awkwardness. In a parental divorce situation, this may be the first time the former spouses have been in the same room in a long while, so be sensitive. The bride and groom will more than likely inform you if there are any such "bad blood" situations.

90-degree angles and with their near arms around each other's backs) and ask them not to move. Then we add the celebrant. They are

Then, we switch to the groom's side and repeat the whole process. After that, we photograph the entire wedding party. Then we

take a few shots of the bride and groom at the ceremony location. Afterward, we will hopefully get twenty-five minutes with the bride and groom alone. We make this session short and sweet. We also inform the couple that we will be happy to photograph any extended family at the reception. This system works 95 percent of the time and clients seem to like it. You get the posed images that keep their parents happy, plus the more contemporary shots most brides and grooms prefer.

Lighting

For family portraits, we use on-camera flash. With everyone in the same plane, our exposures range from ISO 800 to 1600 at f/4 and $\frac{1}{60}$

RIGHT—When the ambient lighting is low, on-camera flash can be used in the creation of your family shots.

BELOW—Maintaining order and control will help you execute posed group portraits more efficiently.

second. We've found there's no time to set up lights.

Large Groups

Every once in a while you will encounter a big event where executing multiple large groups of family shots are necessary to close the deal. Don't fret. As long as you have ample time and a solid plan, it will work out fine. To execute

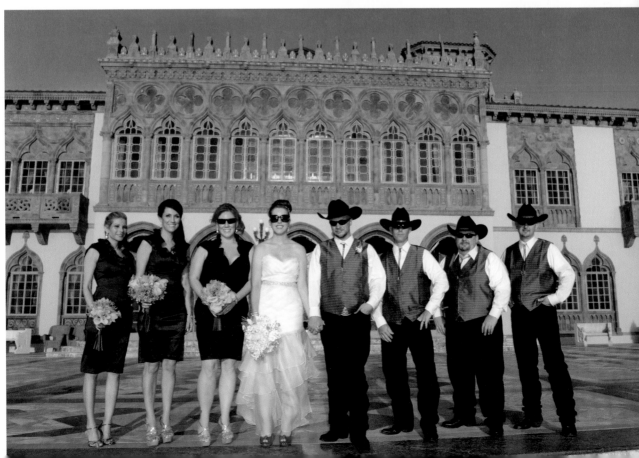

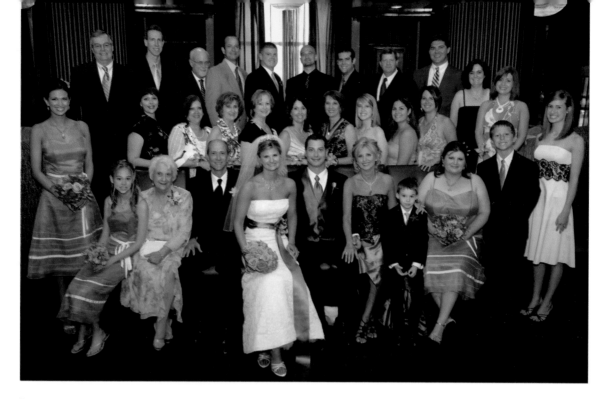

large groups, you need to have multiple posing levels. Churches tend to work nicely, as they usually have steps.

Recently, we had a large family wedding that was held at a church. Because of the limited time allotted, we were only able to do the immediate family shots at the church. However, big family photos were very important for the mother of the bride. Serendipitously, we received permission to use a restaurant to execute these shots, which we were able to complete in just twenty minutes. We had it all coordinated and pre-scouted, and it came off without a hitch. Above is one shot from this session.

Maintain Control

When executing these family shots, you must remain in control. All too often with novice photographers, overzealous family members begin to "help." This is the kiss of death.

Typically we only have twenty-five to thirty minutes with the bride and groom alone, and

When a big family shot is important to your clients (or their parents), planning and organization are the keys to success.

each time Aunt Edna decides you should take a shot with another cousin or uncle or nephew, it eats into that time. Before you know it, they are ready to announce the bride and groom at the reception. The caterer, band, coordinator, and three hundred guests are all waiting and you have not created one nice portrait of the most important people at the event.

Wedding photographers need to pick their battles—and this is one you do not want to lose. Politely tell Aunt Edna that you will be happy to photograph all those family members at the reception, but right now it's critical that you get some wonderful shots of the bride and groom. This usually works and frees you to take the all-important money shots (see chapter 7).

7. The Money Shots

etween the ceremony and reception, you'll have some time to photograph the bride and groom alone. We call the images we create at this time the "money shots" because these are the portraits that brides and grooms will invariably fall in love with and purchase. This is your opportunity to create images that will remind them why they hired you. In most cases, you'll only have about thirty minutes to create

these special images, so you should plan to work quickly.

At the Church

We typically start with a couple of shots at the ceremony venue—perhaps at the altar, if we're at a church. We do these quickly at the end of

When working on location with the bride and groom, keep an eye out for veil-lifting winds.

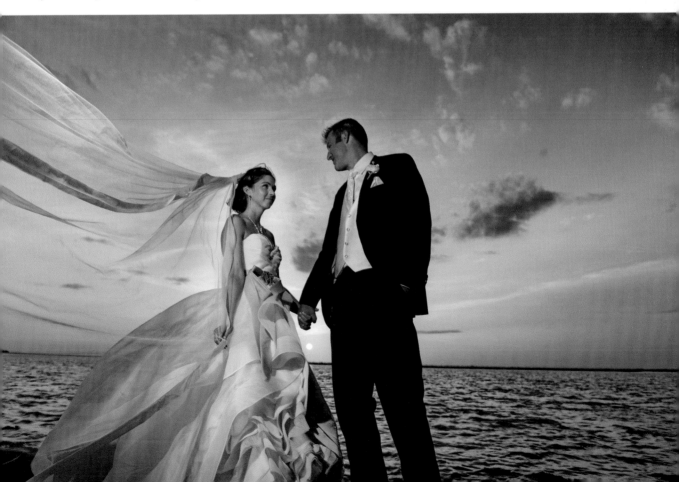

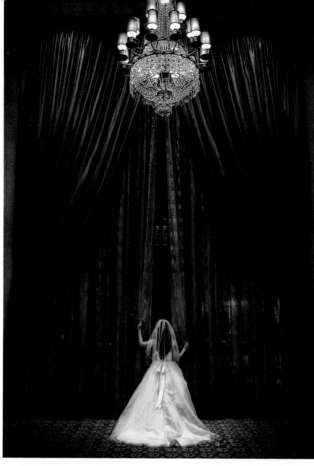

the wedding-party and family shots, because our thirty minutes of post-ceremony shooting time at the venue has usually expired at this point.

Going Off Site

Once we have left the ceremony area and gotten rid of everyone else (including all those "helpers" like Aunt Edna) we can slow down and breathe—though we still only have thirty minutes, so there's no time to get *too* relaxed. If you must travel from the ceremony to the reception site, be mindful to allot extra time in the planning process. Generally we do not venture far from the wedding and/or reception site. Instead, we make the most out of our environment.

When we leave the ceremony site, we look for little kissy moments and record the bride and groom walking from behind. We work around the lighting and do a few closer portraits. We encourage closeness with our posing. We may also do additional bridal portraits because we do not have the restraints we did before the wedding, such as worries about people seeing the bride before the ceremony and/or marring the dress. This does not mean we will trash the dress, but brides are much less concerned about it at this time. This allows us to

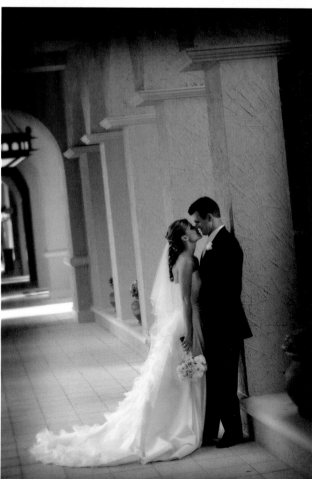

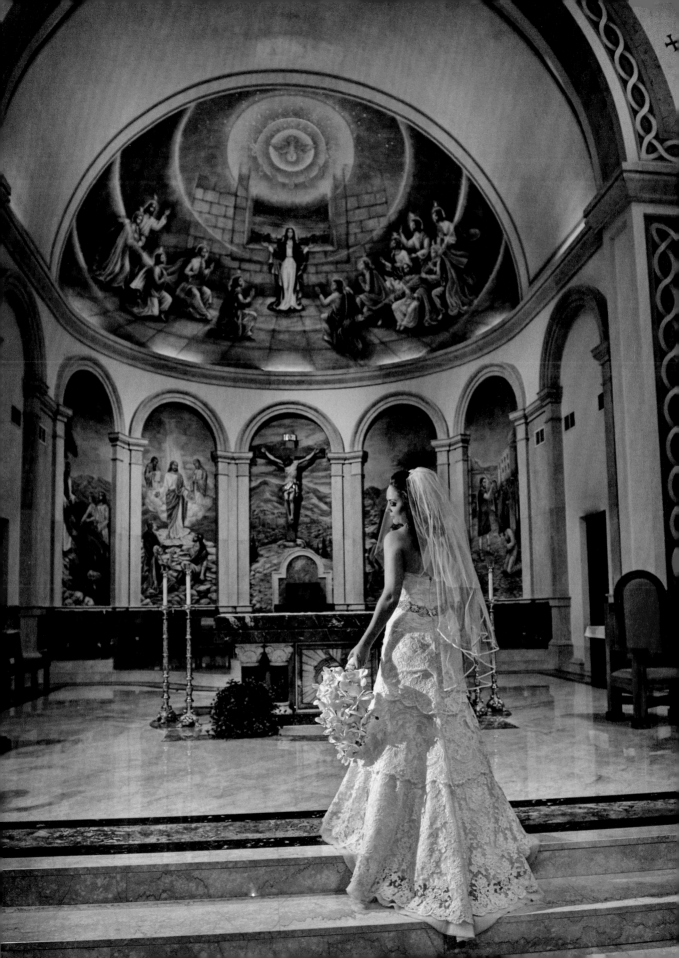

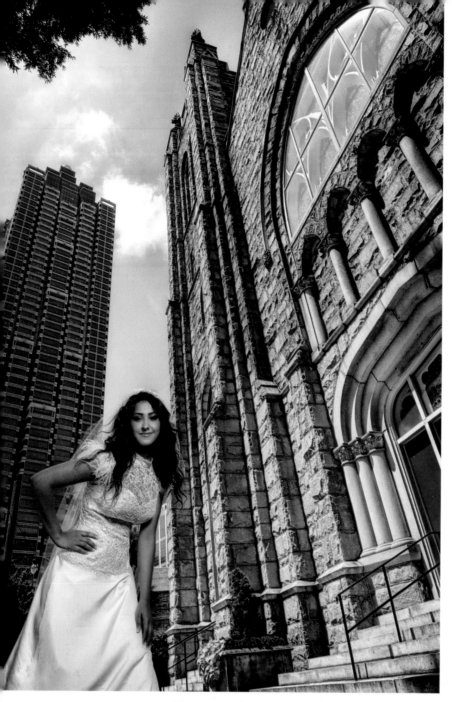

A shot like this conveys a sense of fun and helps to document the location—a fact that will be important to the bride and groom.

photographers develop when they put the camera up to their eye. Train your peripheral vision and know what is going on around you at all times. You must really immerse yourself to come up with the goods consistently (and by "the goods," I mean better-than-average photographs). In the competitive market of wedding photography, this is what you must produce to survive.

During this session, we employ simple but classic techniques. We also love to juxtapose things in unexpected ways, like picturing the bride next to a downtown mural or Harley-Davidson sign. The only rules you have to follow are making images that your clients will love. We try to incorporate fashion and photojournalism, consistently looking for moments that happen naturally. However, we are not afraid to set up a great shot.

try more poses and be more adventurous with our shooting.

Finding Great Backgrounds

When creating these photographs, take advantage of everything in the surrounding environment. Do not slip into the tunnel vision some

To keep things moving quickly, we usually work with one camera, a tripod if the light is low, four lenses (a 24–70mm f/2.8, a 16mm fisheye, 50mm f/1.8, and an 80–200mm f/2.8), and a reflector.

Some locations are fabulously clean and beautiful. Others aren't—in fact, a lot of sites

downtown near our studio are downright grungy. To adapt, we've learned to maximize the good things and minimize the bad. During his seminars, Tony Corbell often shows a beautiful

Beautiful backgrounds are everywhere if you know how to use the scenes around you.

portrait with an out-of-focus green-blue background. The next slide is a wider shot that reveals that the background was really a dumpster. It just goes to show that beautiful backgrounds are everywhere if you know how to use the scenes around you. It is all in how you look at things; if life gives you lemons, make lemonade.

RIGHT AND BELOW—Whether at the wedding or reception location or off-site, use your imagination in selecting great backdrops that create visual interest and communicate something about the day or the couple's passions.

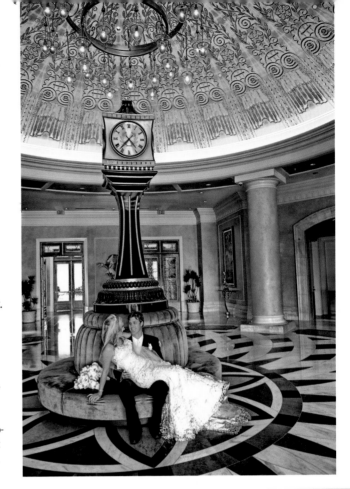

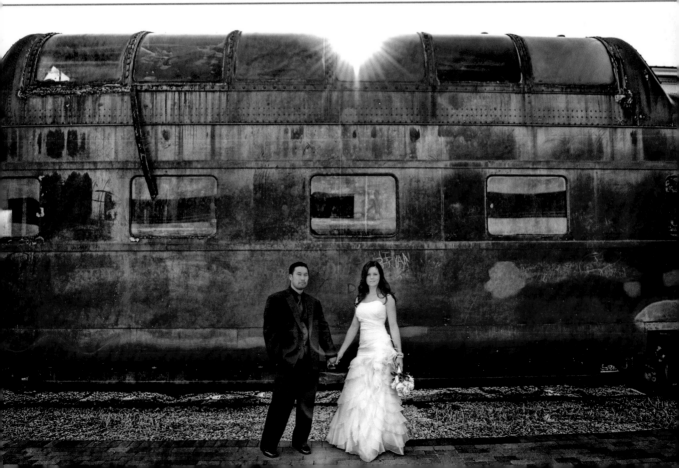

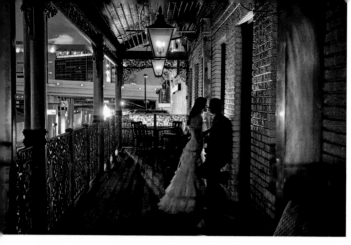

Twilight

During the post-ceremony portrait session, we try to capitalize on available light, especially if we are lucky enough to be working with twilight. This is our favorite part of the day.

LEFT AND BELOW—At twilight, the light is consistent, and the resulting images have a romantic feel that your clients will love.

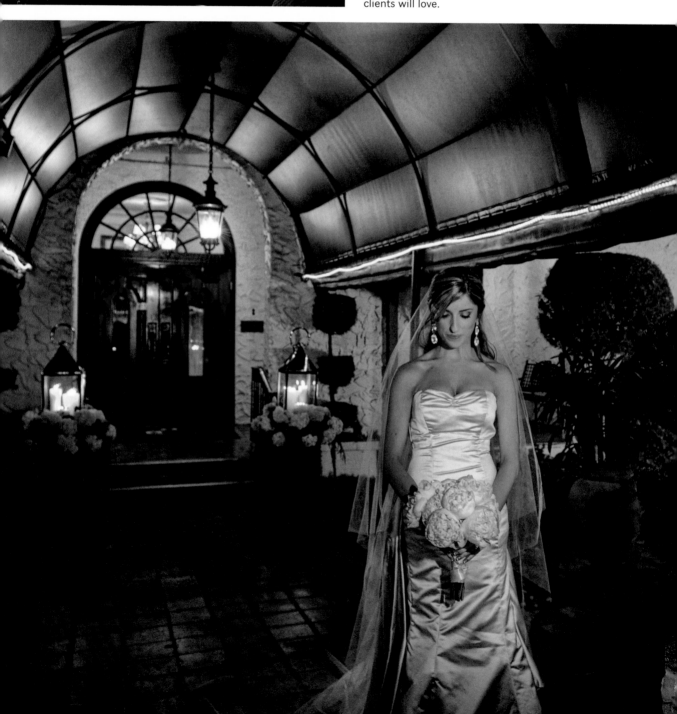

Twilight typically happens about ten minutes after the sun goes down. Unlike sunsets, which are not very consistent, twilight is very consistent. It is the cool midnight blue that lasts about seven to ten minutes. We believe that this time looks great in the digital format. Twilight is a romantic time, and if you execute these shots correctly, you can really set yourself apart from the pack. *(Note:* Typically, we check online so we know ahead of time when sunset will occur. More often than not, twilight occurs after the reception has started. If this is the case, we let the bride and groom get introduced, eat a little something, and then pull them outside for about five to seven minutes for a quick shoot.)

After the money shots are in the can, the bride gets bustled and we run in to document the next part of our journey.

Twilight typically happens about ten minutes after the sun goes down.

Room Shots Before the Reception

Room shots are very important. Whether it is a million-dollar wedding or an event of a much smaller scale, a lot of thought went into the reception room, and it is imperative to document it properly. The challenge is that most rooms are ready only moments before the guests are prepared to be seated. Candles are lit, final touches are made, and there is frenetic activity everywhere. You have servers, florists, and coordinators in your way—and you are the last thing they care about as they are trying to set up a stunning room. If you're lucky, you will

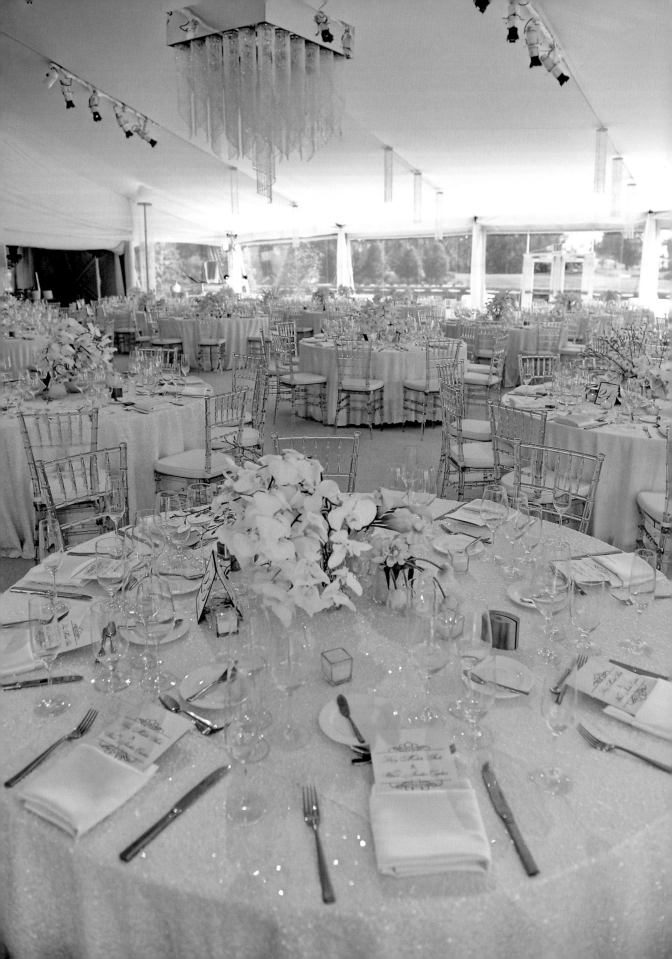

FACING PAGE—Be sure to capture a pristine shot of the elegantly appointed reception area before the guests arrive.

get about three minutes with the room perfect. If you have befriended the banquet captain or hotel manager, you may get the servers out of your shot. (In the old days, photographers would yell and tell everyone to get out of their shot, but that is generally frowned upon today.)

This is our strategy for starting the shooting when we arrive at the reception venue:

Ask the banquet captain or service manager if you can have the room cleared for three minutes . . .

If there is activity all over the room, shoot the details. Do not waste time! Photograph cakes, plates, menus, and tables. Get a shot of the favor the bride's mother made and the handkerchief the groom's grandmother embroidered. All of these little details tell the story. We do most of this shooting with available light and a tripod-mounted camera. Then, we shoot individual place settings, groups of tables, and sides of the room.

When you're done, ask the appropriate gatekeeper (banquet captain or service manager) if

TOP AND BOTTOM—The bride and groom go to great lengths to make sure that every aspect of the reception will be flawlessly executed. Be sure to take the opportunity to capture those details as part of your wedding coverage.

you can have the room cleared for three minutes before they open the doors. You may also want to ask them to adjust the lighting a little. Begin with the widest shots—the staff will begin walking back in at any second, and you may

have to shoot around them. We usually start with a fisheye and then get tighter from there. We use a tripod and employ the timed shutter release on the camera. This helps ensure a sharp photograph.

Once you have the inside documented, don't forget the outside of the venue. Twilight shots of the venue are very dynamic and really help the album flow. And make sure to solidify your relationships with the venue managers by providing them with images of their facilities. If you follow up with these folks after the event, the next time you work at their venue, they will make your job much easier.

BELOW, TOP AND BOTTOM RIGHT—Brides and grooms will be too caught up in the swirl of conversations and activities to truly take the time to drink in the aesthetics of their environment during the reception. Surprise them with some great detail shots for their album that help to tell the story of the day.

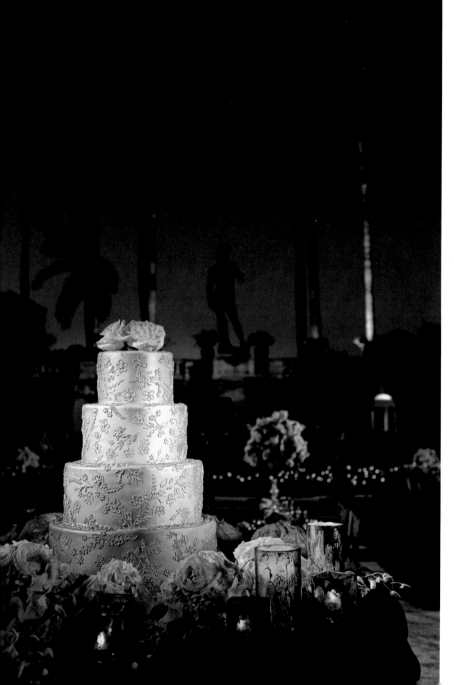

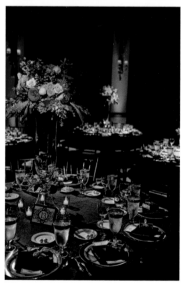

FACING PAGE—Don't neglect to get shots of the exterior of the reception venue. Note, too, that capturing it at different points in the day can yield dramatically different looks.

8. The Reception

The party is on! Just when you thought it was time to relax, it's time for the reception. Hopefully by now you have captured all the necessary room shots (see chapter 7). If not, there is nothing that says you can't do them

TOP LEFT AND RIGHT, BOTTOM—Before the couple arrives, grab shots of the things that make the reception unique and grab some images of the guests socializing.

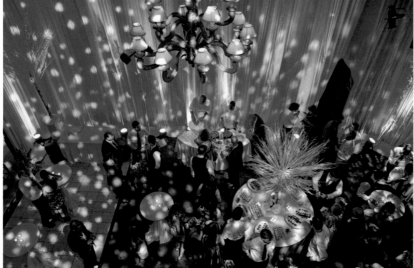

FACING PAGE—Capture an image of the couple before they enter the reception area. It's a must-have shot.

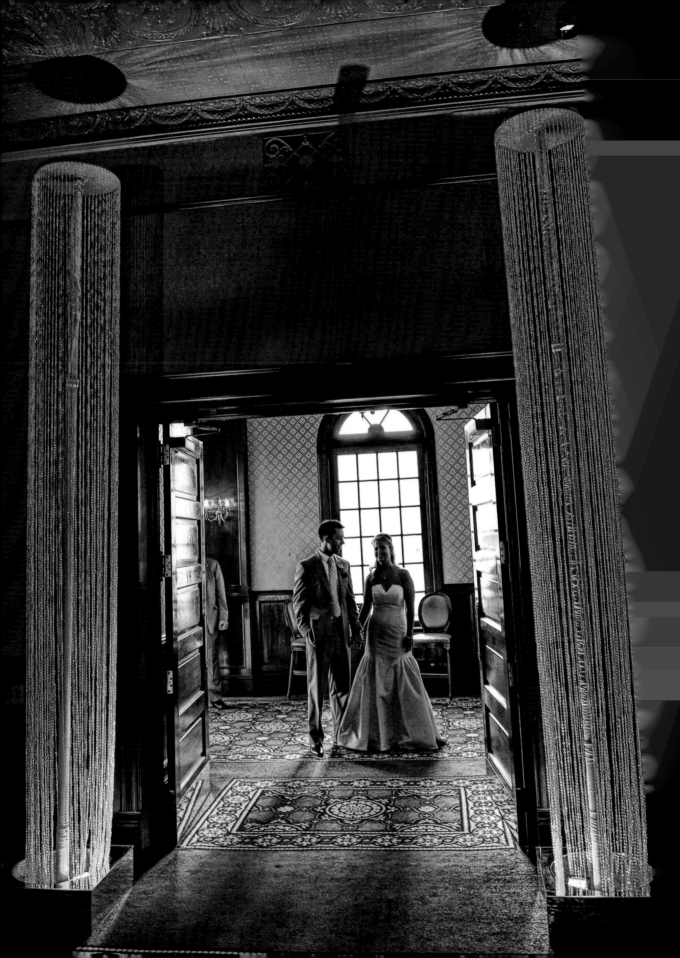

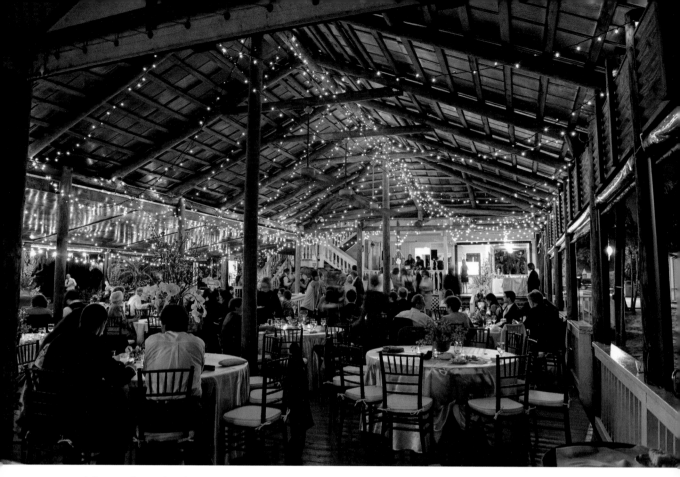

with people in the frame. At most weddings, the reception starts with you and the guests in the reception room waiting for the bridal party to be announced.

Before the Couple Arrives

Before the couple makes their entrance, we try to find a good place to stash our gear that is accessible but out of the way of servers, guests, bartenders, and other venue staff. A remote corner of the room usually works. Remember to keep all bags zipped up just in case any "helpful" hotel staffers try to move it for you. Next, we touch base with the DJ to go over the schedule of events.

Before the couple arrives, we look for fun expressions on the guests' faces and document any crazy behavior as the party gets started. We

If you were not able to get the staff to open the empty reception room up to you for some establishing shots, feel free to create the images with the guests in place.

generally shoot these candids at ISO 1600 at f/4 and $^1\!/_{60}$ second. For these images, we usually shoot with a 24–70mm or a fisheye lens.

Arrivals

Next come the announcements marking the arrival of the bride and groom (or, in some cases, the entire wedding party). The key shot here is the bride and groom entering. We will usually photograph everyone in the wedding party who is announced, but we really want a nice one of the bride and groom. Using a two-photographer system, we like to capture this shot from both the front and the back.

The First Dance

Once the announcements occur, the bride and groom usually go right into the first dance. When photographing this, we try to capture a nice wide establishing shot as well as some tighter shots showing the emotion of the moment. You will have plenty of time to achieve both, so relax and tune in to your surroundings. In addition to the shots of the bride and groom, do not overlook reaction shots of the parents, bridal party, family, and

. . . capture a nice wide establishing shot as well as some tighter shots showing the emotion of the moment.

RIGHT, BOTTOM LEFT AND RIGHT—The bride and groom's first dance is a romantic event, and getting a photograph that documents the moment is a must.

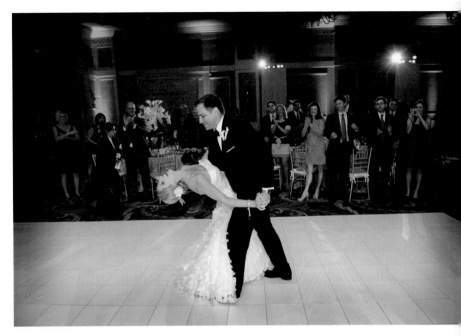

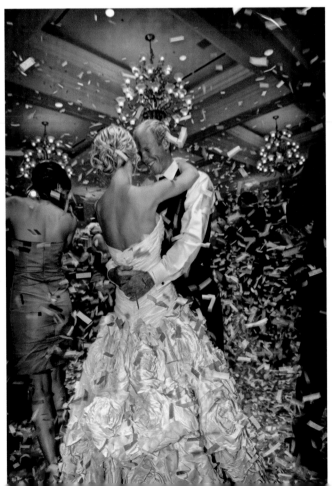

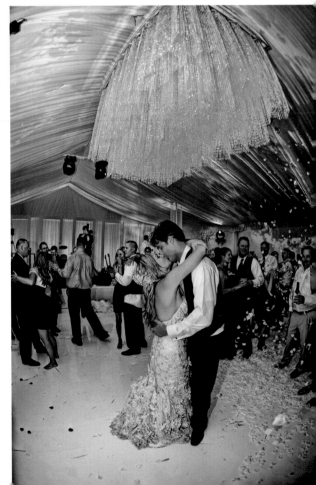

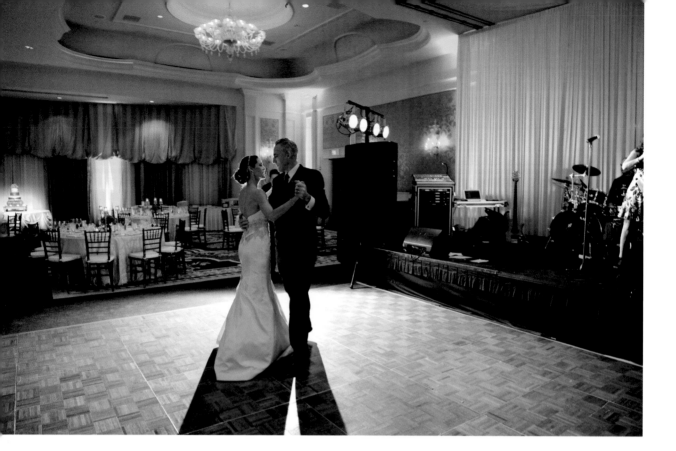

guests. These can be priceless and make smooth transitions for the album.

The Toasts

Next are the toasts. We shoot these from two different angles, covering both the toasters and toastees. Then we capture them all together. Again, do not linger in front of the guests; they did not come there to see your backside. Move in, get your shot, and move out. Zero in on reactions—especially those of the parents and family. Look for tears, smiles, and laughter. It's all about the emotion.

A Quick Break— and Some Makeup Shots

When the toasts are completed, the photographers may get a little break. Once the guests are started on their dinners, the venue will typically

ABOVE—Converting this first-dance image to black & white lent a classic, elegant feel to the photograph.

FACING PAGE—Don't miss the chance to get some dramatic shots after daylight wanes.

have vendor meals available in the back of the facility. It may be tempting to take a load off and chow down, but the savvy photographer will not rest just yet. This is the time to make up anything you might have missed in the whirlwind you just experienced. Get that cake shot you skipped or capture the twilight shot of the exterior of the venue. Make sure your gear is in order. Only then should you go check on the plates they have waiting for you in the back.

Try for Twilight Shots

At this time, we decide if we want to pull the bride and groom aside so that we can capture a

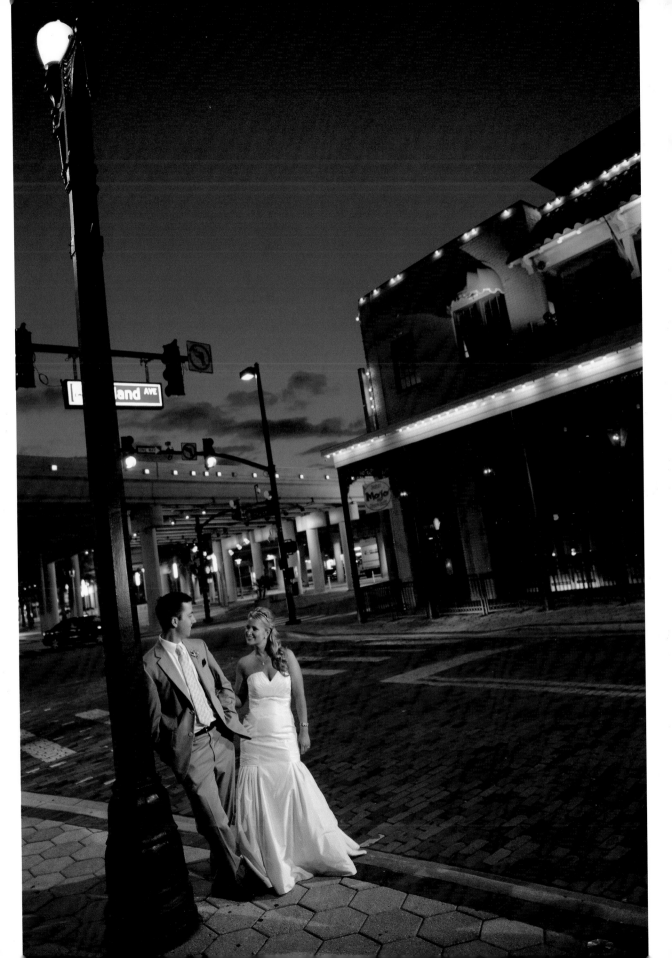

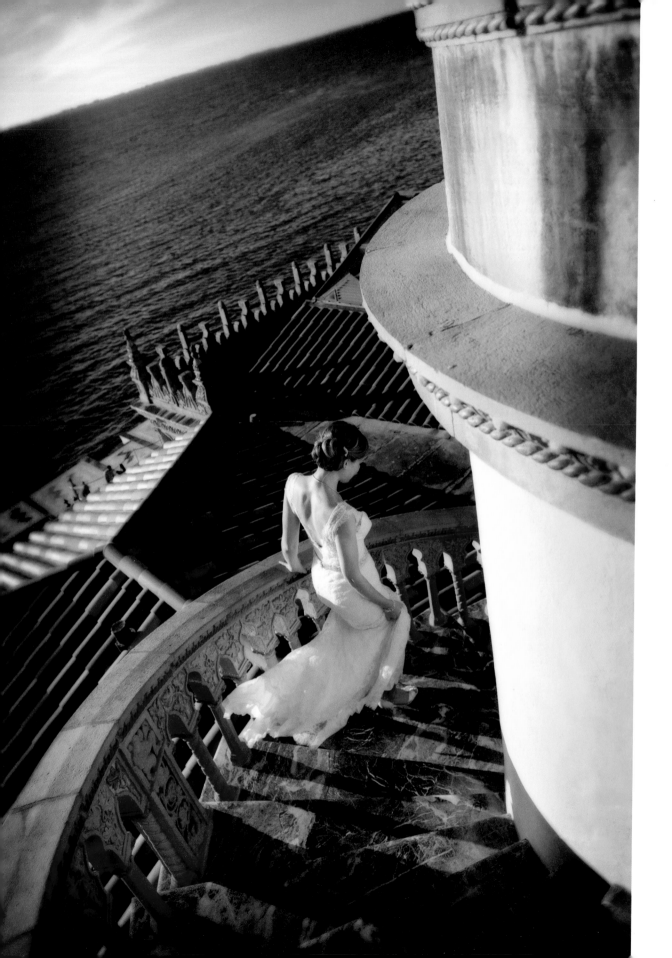

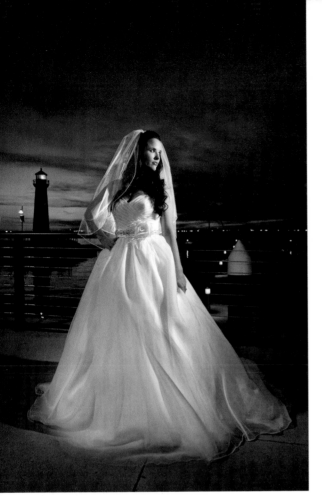

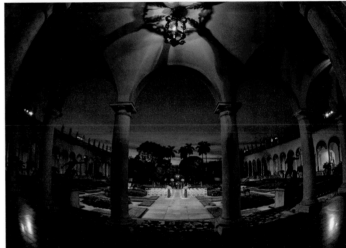

ABOVE, TOP AND BOTTOM RIGHT—
Dramatic twilight and night images
are a beautiful counterpoint to the
ceremonial images shot early in the
day.

FACING PAGE—Scout out incredible
portrait locations at the venue so
that you can make quick work of
getting high-impact shots in no time
at all.

twilight or nightscape shot. The bride and groom usually eat first and then mingle with their guests, so there is a brief opportunity to pull them away for this shot. We work fast, trying to get these shots done in less than ten minutes. If the bride and groom are gone from the reception for very long, it disrupts the flow of the party. Remember that everyone there has an agenda, including the DJ, caterer, venue manager, and coordinator. If you disappear with the bride and groom for too long, it really can hurt the timing of the reception.

If you decide to execute these shots, go out and scout your locations while the bride and groom are eating. Test an exposure using your assistant as the subject. Then, when you are ready, you can just plug the bride and groom into the shot and get them right back to the party.

Parent Dances

After dinner (hopefully you had a chance to choke down a little something to eat), the parent dances start. This is an excellent time to get some emotional shots. Key in on the father–daughter dance. There are often tears here. Be ready for a kiss on the cheek at the end of the song.

The Party Starts

After the parent dances, the real party begins. We like to have fun with the guests, but we also watch the bride and groom like Labrador retrievers. If they make eye contact like they want a photo with some friends, we are right there. We also stalk the dance floor looking for interesting shots. We look for different perspectives and never stay in one place too long. We like to climb up on chairs or DJ speakers and shoot over the crowd using wide-angle or fish-eye lenses. (Do Hail Mary shots like this at your own risk—if you fall off a speaker, you will be the talk of the industry for a few weeks!)

As the party progresses, people lose their inhibitions and you can get some crazy shots.

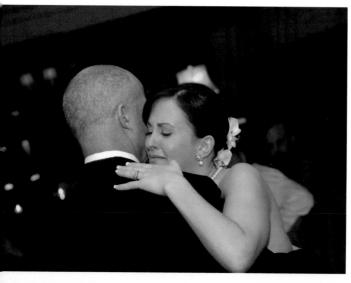

LEFT—The parent dances typically come after dinner and can be filled with emotion.

BELOW—Be on the lookout for exuberant party guests who would be happy to pose for pictures.

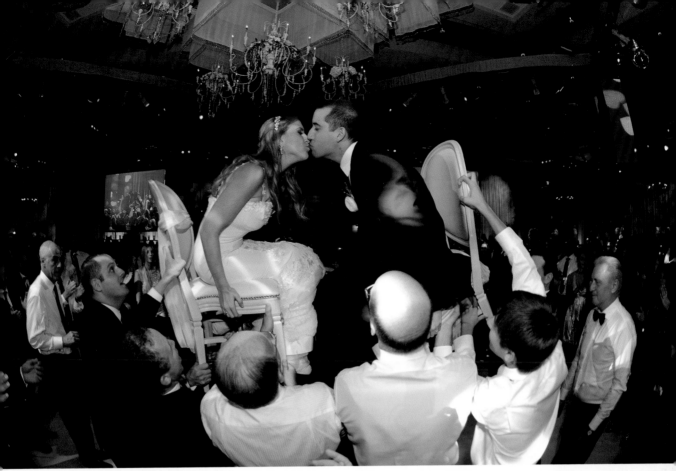

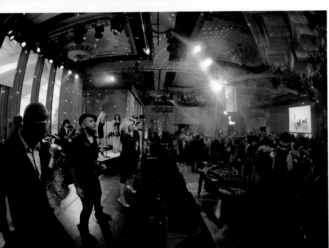

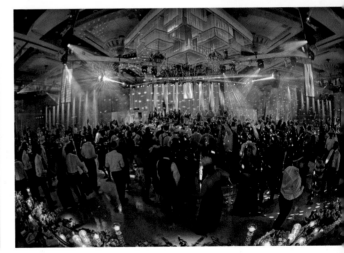

Capture photos of the entertainment, the crowd, and any traditions or antics as the night wears on.

However, do not lose your awareness of everything else happening around you. Just because you are in the mosh pit, do not overlook the grandmother saying goodbye as she leaves. It is your job to capture everything; to do so, you have to increase your awareness.

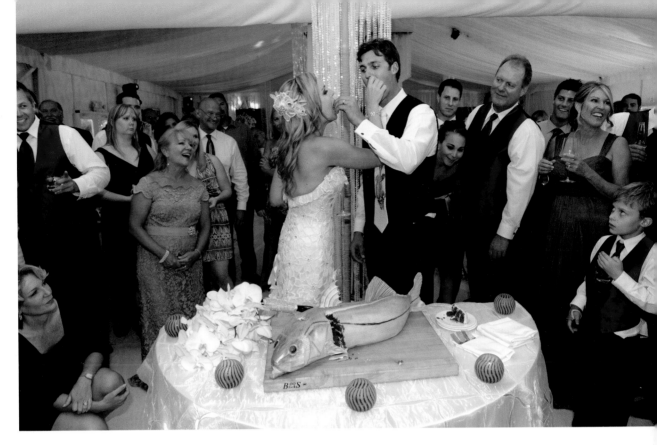

FACING PAGE AND ABOVE—The cake is an iconic part of the wedding reception; photos of the unique design and details—and the cake cutting—will be a critical part of the wedding album.

Cake Cutting

Besides the fun and dancing, there are a few key aspects of the reception left, including the cake cutting, the bouquet and garter tosses, and the grand exit. We usually document the cake cutting at f/4 for $^1\!/_{60}$ second. Make sure you have the best vantage point for the shot. Wedding-goers are often a little inebriated at this point and do not mind jumping in front of you. Just politely remind them that you are there to take photographs for the bride and groom. That usually does the trick.

In the old days, there was an exact pose for the cake cutting. You had the groom farthest away from you on the right side of the cake.

The couple would put their arms around each other and hold the knife with their outside hands. This would show off the bride's ring.

These days, our studio goes with the flow. If the couple asks us to pose them, we will do so in the aforementioned manner. However, we

. . . if they are not posed, we might be able to capture a more natural, genuine moment.

prefer just to document at this point. The bride and groom are adults who are capable of cutting a cake—and if they are not posed, we might be able to capture a more natural, genuine moment. Also, be ready for the cake smash. It does not happen a lot, but when it does, it can make for some exciting photographs.

Garter and Bouquet Tosses

The next events are the garter and bouquet tosses. The DJ will ask someone for a chair, and the bride will sit. Then he will play some bawdy music while the groom removes the garter. This can make for some funny shots. Watch, at the end, for the garter to inevitably end up in the groom's mouth.

Next, all the single ladies line up, and the bride throws the bouquet. Using our two-photographer approach, one of us photographs the bride throwing the bouquet and the other

BELOW, TOP AND BOTTOM RIGHT—Bouquet and garter tosses aren't seen at every wedding these days. When they are, be sure to photograph the action. It's good insurance to capture portraits that show the bouquet—and shots that feature the garter. Though they may not play a prominent role in the reception festivities, they matter to the bride.

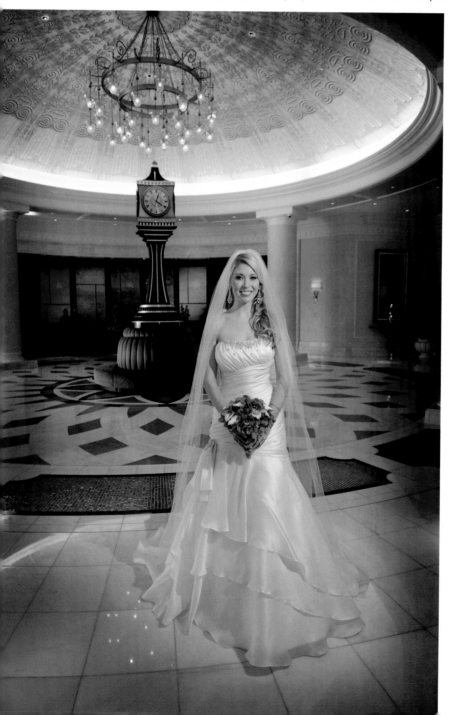

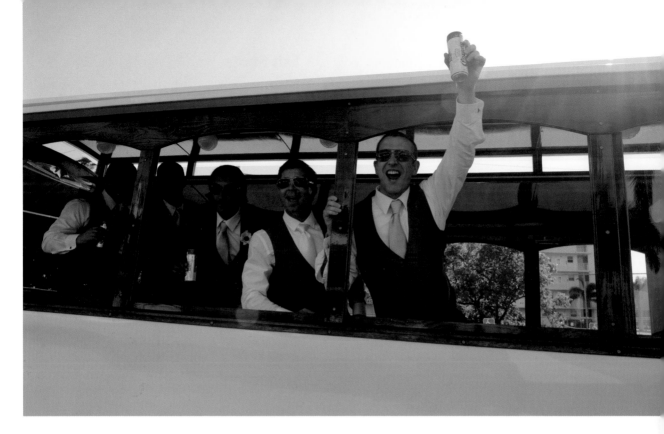

photographs the single girls trying to catch it. If you are by yourself, you can capture a wide shot from the side that includes both the throw and the catch. Timing is everything; you will probably only get one shot.

During this time, we do not mind getting people together for "happy faces" shots.

After the bouquet toss, all the single guys line up and we repeat the process with the groom tossing the garter. Sometimes we also get the groom with the garter before he throws it.

Once we have the people who caught the bouquet and garter, the DJ sometimes brings back the chair and has the woman who caught the bouquet sit in it. The gentleman who caught the garter will be instructed to place it

As the reception progresses, continue to get shots that focus on the members of the wedding party—and the many guests enjoying themselves.

on her leg. The DJ will usually give him some instructions to the effect that every inch he places the garter above the knee will be seven years good luck for the bride and groom. It is nice if the bride and groom are standing behind the newly formed couple while this is taking place. These shots are a lot of fun, and with the bride and groom behind them you can incorporate their reactions as well.

Back to the Party

After this frivolity, the party is back on. During this time, we do not mind getting people together for "happy faces" shots. These photos always work in the album, and the guests seem to love doing them. We just ask people to lean

together and then click. Other things to look for are the bride and groom or family members playing with the band, surprise announcements (such as guest birthdays), and Uncle Lou out of control on the dance floor. Be ready. Be aware.

Exit Shots

As the night winds down, the reception will usually conclude with some type of exit or other official ending. It may be as simple as a last dance with flower petals tossed, or it could be a sparkler exit. Who knows—it might even be a helicopter picking the couple up. Whatever it is, be ready and position yourself to capture it.

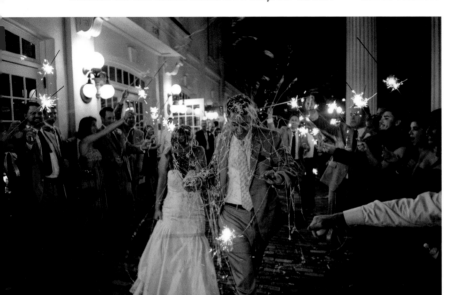

LEFT AND BELOW—As the festivities wind down, capture final images of the bride and groom.

FACING PAGE—Modern wedding photography is all about celebrating the individual. Take every opportunity you can to create shots that won't appear in other couples' albums.

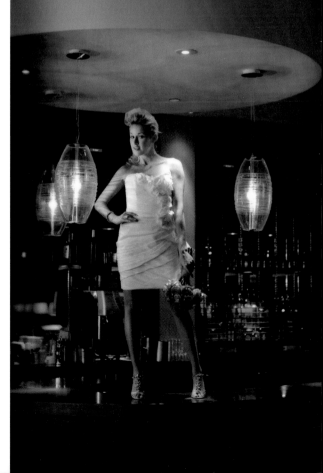

Check Your Gear

Now that the night is over, do a quick inventory of your gear. Make sure you have everything. Remember: have a place for everything and put everything in its place. We have a memory card wallet and we confirm that all of our cards are accounted for and in the wallet. You can insure your gear against loss or theft, but if you misplace your cards, you have trouble. If anything is amiss, deal with it right away. It is a lot easier to retrace your steps then and there than to return the next day after everything has been cleaned and moved.

Secure Your Images

At the conclusion of the event, it is critical to secure your images. We tend to download our images that night because we enjoy seeing what

LEFT, TOP AND BOTTOM RIGHT—Immediate backup is your best bet to ensure that the couple's gorgeous images are secure.

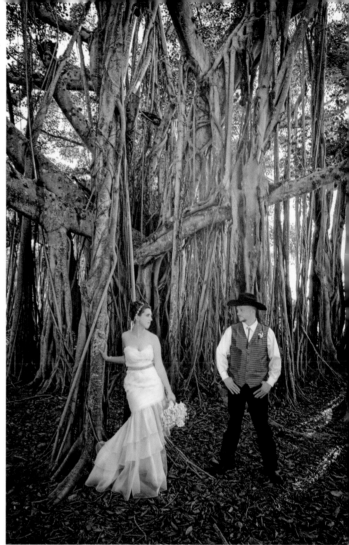

ABOVE AND RIGHT—We back up both unedited images and those that have made it through the postproduction phase. This way, we will never have to redouble our artistic efforts if any worst-case-scenario events unfold.

we have captured. However, it is okay to wait until the next morning. What's essential is that you have an established process.

It's a pretty rudimentary system, but it has worked effectively so far— knock on wood.

We download all of the cards onto our Macintosh computer's hard drive. All of our cameras are synced to the same time, making it easy to organize the files chronologically. We then use a program called Photo Mechanic to edit and rename our files (you could also use Adobe Lightroom or ACDSee). As we download each card, we rename it and then bring in another card.

Once everything is downloaded and renamed, we burn a backup DVD or DVDs. These are labeled as originals and stored in a CD/DVD binder in a location other than our studio. These are emergency backups of the original files that we can always go back to—even in the event of a fire or other catastrophe at the studio. We also back up to DVD our polished and edited versions of the files, which are kept in a binder at the studio.

This gives us backups in triplicate in multiple locations. It's a pretty rudimentary system, but it has worked effectively so far—knock on wood.

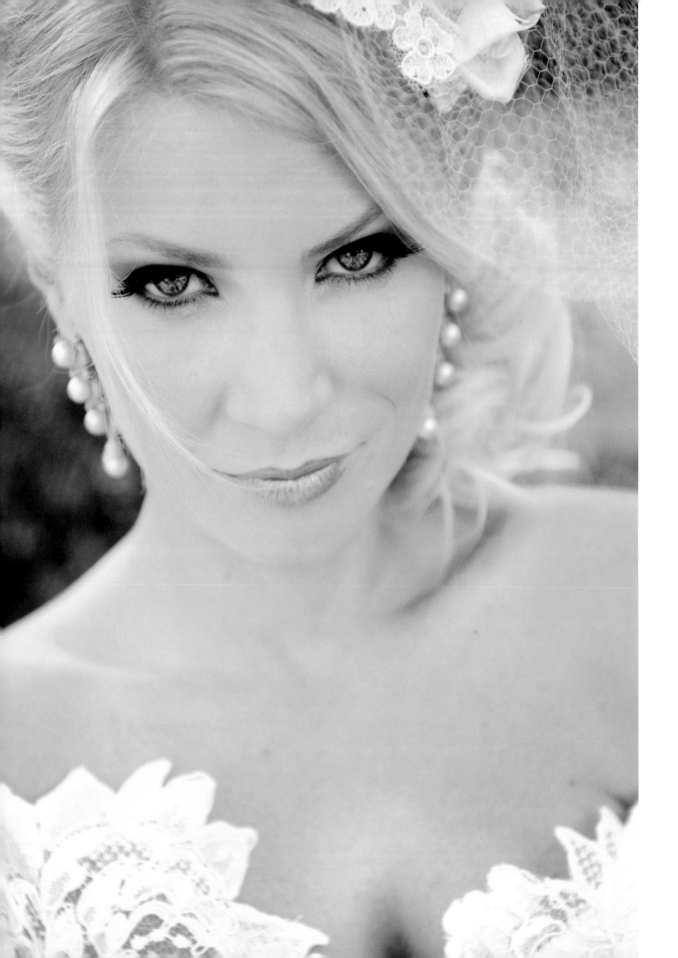

9. Time-Saving Strategies

When I was a young photographer at Walt Disney World, I was sent to photograph a group of three hundred people for the United Way. This was considered a one-man job, so I set out with my Hasselblad and two

FACING PAGE—Capture close-up portraits with great eye contact when you can. These images have great appeal.

BELOW—You might be lucky enough to capture an improptu kiss—but if not, the moment is simple to re-create.

Photogenic power lights. On these jobs, you typically had some time beforehand to choose where you would shoot and do a Polaroid. When it was time to execute the shot, however, you would only have about ten minutes—and often less. That is about how long it takes for a group of three-hundred people to get bored and start heading for the cocktail area.

To get the shot, I had to climb into a lighting tech booth overlooking a dance floor that would accommodate everyone. By looking down at the clients, I could effectively pose

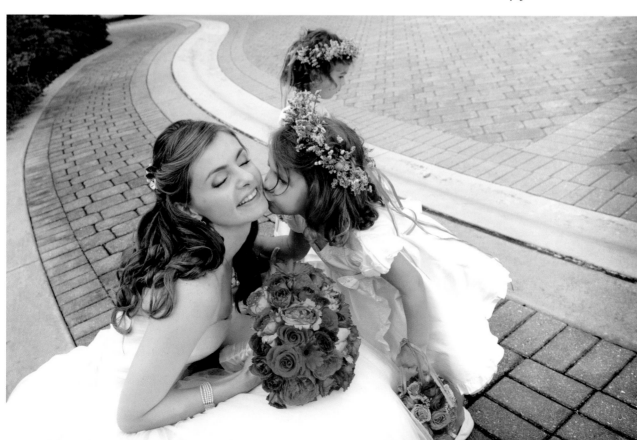

everyone and place the key players in a prominent position. I got there early, made friends with the lighting guys, set up my lights, and did a Polaroid. I was ready to rock-n-roll—at least that's what I thought.

The clients came in and I executed the shot, then crawled down the catwalk. However, when I went to roll out the film, nausea ensued. You

You have to recognize your mistakes or successes instantaneously and not squander your time.

see, Hasselblads are excellent cameras. I really love them. However, there is one thing about them: when you load the film, you need to wind the crank to frame number one or you are just

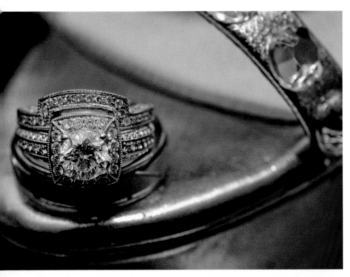

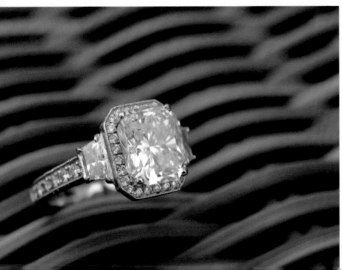

shooting on paper. In fact, there are usually about six frames on paper before you get to the film—the exact number I had just shot. I had just shot the group on paper. This wasn't good, and I was sick to my stomach.

I explained the situation to my liaison, however, and he quickly told the client that some bigwigs had arrived late and we needed to do the shot again. Everybody grumbled, but they reluctantly agreed—and a bullet was dodged.

The point to this story is that you can almost always make something up if you need to—especially at a wedding. The key is that you have to recognize your mistakes or successes instantaneously and not squander your time. You never know when you might need an extra ten minutes to reshoot something. Time is your enemy because it is the one thing that you will never be able to control.

This leads us to our seven strategies for combating Father Time. They are:

1. Be an opportunist.
2. Listen.
3. Use available light.
4. See beyond what is there.
5. Recognize success or failure instantly.
6. Train your anticipatory and reactive skills.
7. Become one with your assistant.

Be an Opportunist

How many times do we arrive to find that the bride is not ready? Instead of waiting there for an hour, shoot. There is always something to capture. You need to train yourself to be an opportunist. Look closely for anything that will help tell the story of her day. Details make excellent transitions in the album and are effective emotional reminders to the bride and groom of

TOP AND BOTTOM—When there is a lull in the action, consider getting detail shots. Any of these images could be captured while you wait for the bride to finish her preparations—and shots like these will make great additions to the couple's wedding album.

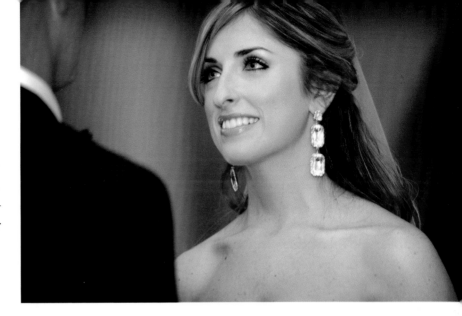

their special day. Capture the bridal bouquet lying on a table, a note from the groom, a card from a friend, the bride's shoes, her necklace, the dress, her grandmother's brooch. After you make these shots, walk around and get some establishing shots. Never rest and never waste any of that time.

Photojournalists who visit the Amazon or cover wars sometimes live with the indigenous people for two weeks before they even pull out their camera. That way, the people are comfortable with them; they break the shield of self-consciousness so they can get to the soul of their

After you make these shots, walk around and get some establishing shots. Never rest and never waste time.

subjects. You do not have that luxury. What you do have, however, is the possibility of an engagement session before the wedding. Engagement sessions provide more than just lovely pictures that can be displayed at the wedding; they establish a level of trust between you and your clients. If done

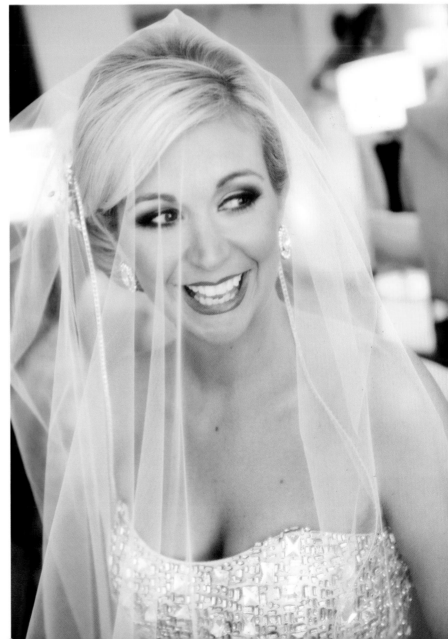

TOP AND BOTTOM—Authentic moments are priceless. Capture sincere expressions and interactions.

properly, the bride and groom will be a lot less self-conscious. It is hardly a two-week acclimation period, but it helps immensely.

At the wedding, you must be like a hunter stalking his prey. This sounds a little dramatic, but it is true. You must use all of your senses to pick up on the little nuances that are happening around you. The wedding ritual is abundant with opportunities. Train yourself to see, hear, and feel them. This way, you will always come away with above-average results, no matter what the wedding throws at you. You will also begin to develop your own unique way of looking at things. This is the beginning of developing your own visual style.

Real moments are priceless. Always be on the lookout for a mother's tear, a smile from a friend, or the father's first meeting with his daughter in her dress, and don't relax between them. We think it is perfectly acceptable to make things happen, if necessary. You do not need to be obtrusive; on the contrary, you must be as unobtrusive as possible, but how hard is it to say, "Hey, can you hug her again?" or "Do you mind lacing up her dress by this window?" With suggestions like these, you can subtly take charge of the situation. You have finite time parameters and only you know what you have in the can. So step up and use your time wisely.

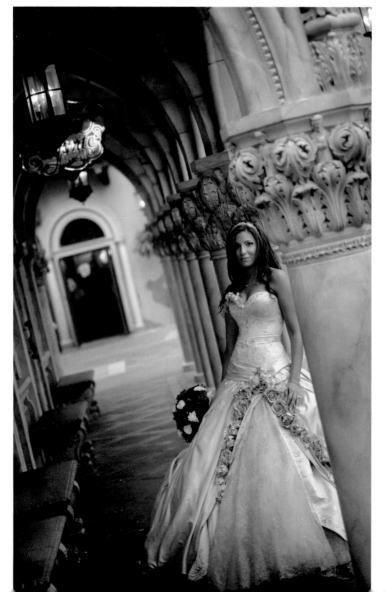

Listen

I have mentioned the need to use all of your senses. Your ears, in particular, are very valuable at a wedding. When you first arrive, listen. Introduce yourself and your associate, but after that try to be a fly on the wall. Eavesdrop on some of the hot issues of the day. Find out who is getting or not getting along with whom. This will help you know who not to pose by whom. If you train yourself to listen, you'll usually know everything you need to know about their family by the time the ceremony starts.

We love to call people by their names; it invokes an instant bond and people are more likely to listen when you address them by name, making your job a little easier. Sometimes, however, we forget a name. It may be necessary to simply ask the name again, but if you just listen, chances are the other folks in the room will call that person by his/her name eventually. Just by tuning in, you will be the hero who remembers everything about your clients.

Use Available Light

The best advice I could give a new photographer is to turn off your flash. Start shooting

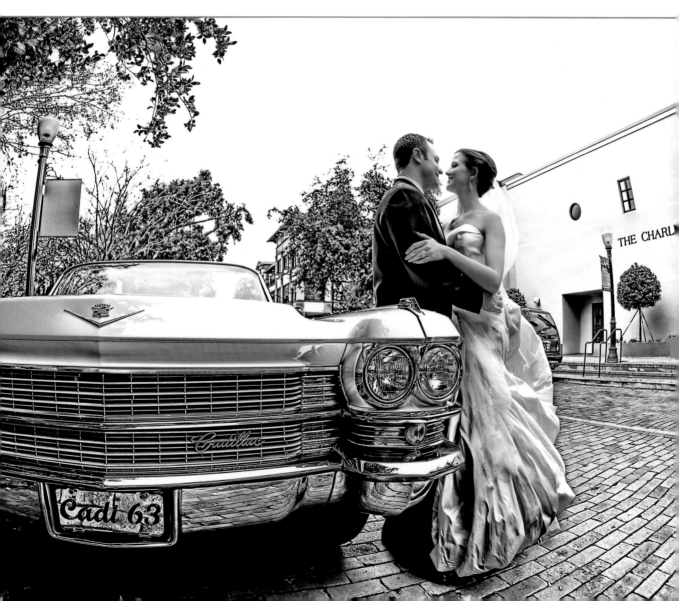

LEFT AND BELOW—Natural light is great for ease of use—and the results are extremely flattering when the conditions are right.

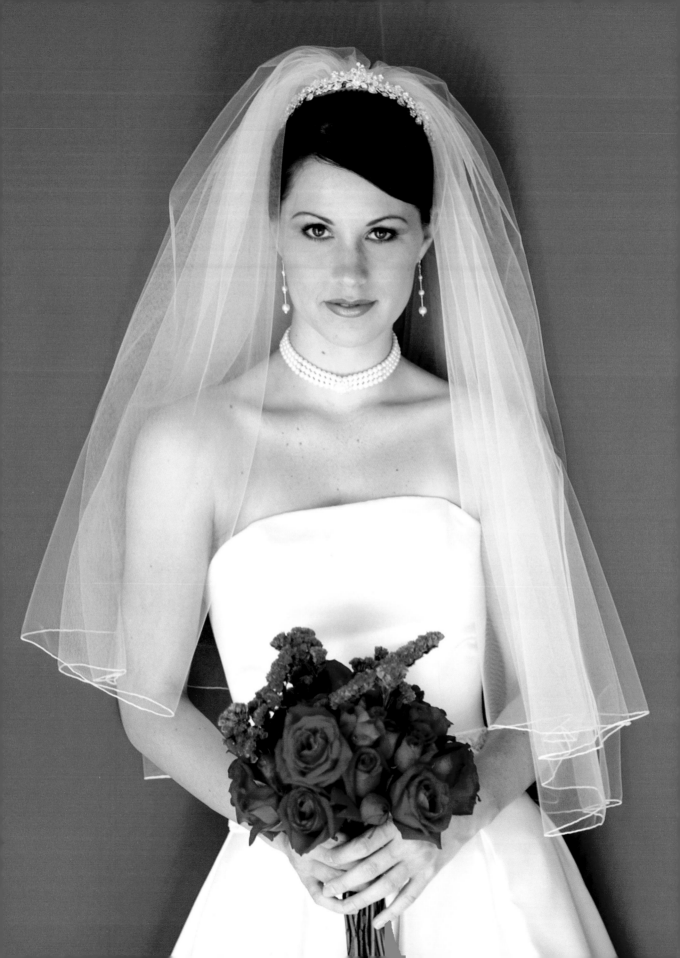

FACING PAGE AND ABOVE—Great photographic opportunities are all around you. This location (above) might not have looked like much at first glance, but there was great window light and a vibrant red wall. The result is a memorable portrait.

Training yourself with this type of mindful visualization empowers you to pull wonderful images out of your hat . . .

without one and you will experience much more natural results. It requires good technique, but if executed properly, the resulting photographs will be dramatic. With available light, there's nothing to carry and no extra equipment to slow you down. The key to using natural light successfully is training your eye to see it. We have looked at this topic throughout the book, and we will revisit it in greater detail in chapter 11.

See Beyond What Is There

"From there to here, from here to there, funny things are everywhere." That is what Dr. Seuss thought about funny things. I see photographic opportunities the same way as he saw humor. They are all around us. We mindlessly walk by them all day long.

At Disney, I was trained early on by some wonderful photographers. One in particular was Michael Glen Taylor, who revolutionized the way I looked at everything. Michael taught me to work around the light—to find great lighting and then look for the background. Michael would walk around with a model and say, "Stop, that is it!" His students often could not see it until he pulled a Polaroid—and then we were all blown away. He would show us slide shows of beautiful portraits and we would think he had shot them in an incredible botanical garden. The next slide, however, would reveal that the portraits were actually taken in a not-so-nice city park with trash cans and homeless people just outside of his compositions.

The point is this: training yourself with this type of mindful visualization empowers you to pull wonderful images out of your hat, no matter the situation. Whether it is raining, snowing, full sun, cloudy, or a level-four hurricane, you have options.

I was once commissioned to take some photos for a wedding magazine at an old courthouse in downtown Orlando. Upon entering the courthouse, I noticed the vibrant red corner that was lit perfectly by natural light from a window. I placed the model in the corner and had an assistant hold a reflector to pop a little light into the model's eyes. In about four minutes, we had the shot (it would have taken only two minutes, but the automatic door kept closing on me, so we had to be patient!). How many of you would have walked on by?

Recognize Success or Failure Instantly

Digital is a wonderful tool. The instant feedback provided by the LCD and histogram is one of the best tools at your disposal for ensuring more professional results. You can quickly zoom in to check your focus, see if the eyes are open,

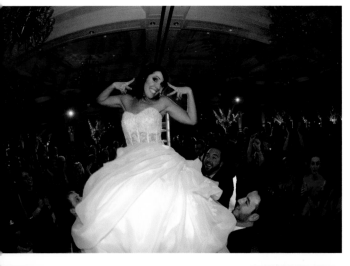

and verify your exposure in seconds. (Just think about all the money and trouble we used to go through to shoot Polaroids!)

With digital, you know when you have the shot and you can move on. This enables you to try things outside of your comfort zone. If you are too far off the mark, your LCD/histogram will tell you and you can instantly make corrections or abort the effort. This saves valuable time, which is imperative for today's weddings. Brides want to enjoy their day, and they will not endure a three-hour photo session. They want to have fun—and if you want to stay competitive, you will let them.

Practice Your Anticipatory and Reactive Skills

The sixth strategy for maximizing your productive shooting time is anticipatory and reactive training. The wedding ritual is rich with events that happen time and time again. As a pro, you need to be in the right place at the right time and ready to capture some real emotions.

The first moments typically happen as the bride is getting ready—a mother's glance, a nervous bride, the bridesmaids laughing. Be ready and position yourself accordingly. The ceremony is also ripe with opportunity. We always shoot their reactions when the bride and groom first see each other. Couples really love these shots, because they are usually so entranced by the moment that they hardly remember it.

Next, the minister will usually say, "Who gives this woman to this man?" Typically the dad will say, "We do," and give his daughter a kiss on the cheek, then shake the groom's hand. Boo-ya! Another moment captured because you were ready. But wait, there are more. We also love to capture close-up reactions of the guests.

TOP AND BOTTOM—Have your gear ready to capture spontaneous moments that will get a smile from the bride and groom.

During the major ceremony points (vows, ring exchange, kiss) you can usually get some excellent expressions.

Immediately after the ceremony, if you follow the bride and groom, you may be rewarded with some truly giddy, love-struck expressions. The bride and groom will still be totally wrapped up in the moment and probably won't even realize you are there, documenting every moment. After the ceremony, people will congratulate the bride and groom. These can be very nice images as well.

At the reception, the first dance and parent dances prompt priceless expressions. Following the toasts, you can also expect to see some photogenic hugs. Be ready.

There are wonderful, memorable moments at every wedding; these are just some of the many expected ones. The point is, be ready! Anticipate, then execute. You might not be right all the time, but when you are, you will have positioned yourself for success. Wedding photography is a thinking person's sport. By anticipating the action and nailing the shot, you can save yourself the time and headache of having to "restage" something—and probably come away with some real emotions in your photos.

Be One with Your Assistant

Being one with your assistant is a valuable time-saver. How many times have you looked up and seen them in your viewfinder? Curses, foiled again.

Good associates are hard to come by. If you find a responsible one with a good eye, nurture them. After each wedding, review your shots together. Identify what worked and what did not. Grow together. If you want them to be as focused on the wedding as you are, you must

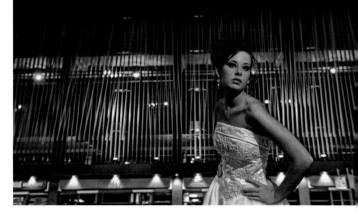

With the tips in this chapter, you'll learn to capture images more efficiently and effectively.

give them plenty of incentives (encouragement, money, support) to do well. Give them some freedom, as well. In my early days, I wanted my associates to shoot and be just like me. Now that I am a little older and wiser, I let them be themselves and am amazed at some of the results. Work toward a more symbiotic relationship where both parties benefit from the experience.

Once you have a good assistant, you'll find they are an invaluable time-saver.

All in all, there must be good communication. Hand signals can be really helpful, since screaming across the church during the ceremony is not acceptable. Basically, you just want a plan of action, so you are not both shooting the same exact shot. Once you have a good assistant, you'll find they are an invaluable time-saver. How else can you be in two places at once?

Like death and taxes, the passing of time is inevitable, so don't waste it. These strategies will help you maximize your productivity at the wedding. They are tried-and-true techniques for being successful as a wedding photographer.

10. Posing Techniques

*L*et's face it: it is easy to create a likeness of a person. To make a portrait that they truly love . . . now that's a different story. Our subjects come to us to document them in some stage of their life. They also hope that we will do so in a flattering manner. There are a few simple techniques that our studio employs to make this happen.

Camera Angle

The camera typically adds a few pounds, something most clients won't appreciate. To compensate for this, we tend to use a higher camera angle. Try this experiment: Ask a friend or family member to sit on a chair. Then, while you are standing above them, look

A straight-on pose can work well for slender subjects. In this pose, the bride held her arms slightly away from her body. This helps to define her figure.

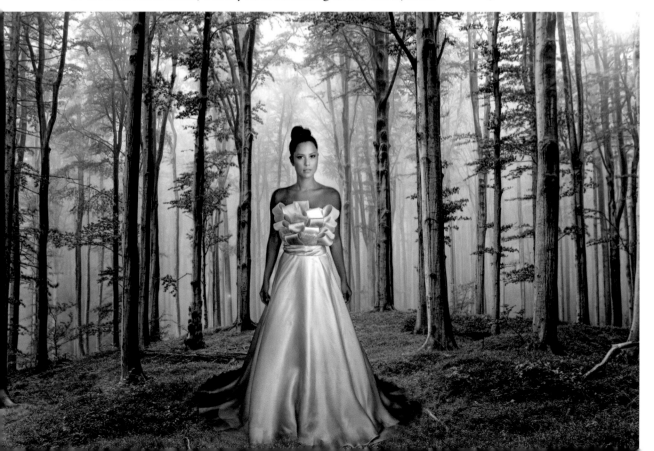

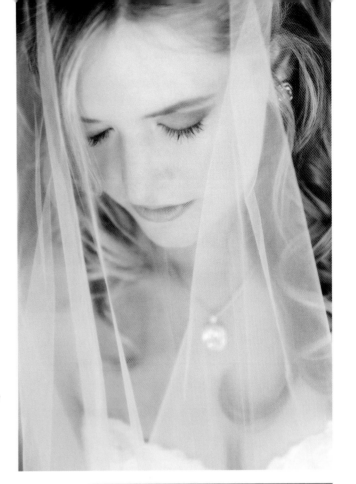

down at their face. Next, switch places and look up at their face. Which view is more appealing? Chances are when you were looking down at them, they looked much better. Upward angles may be great for supermodels, but for a normal person it exacerbates any facial flaws and makes that double chin a quadruple chin.

Where you position your camera, what lens you use, and how you light your subject all have a profound effect on the outcome of your photograph. Typically, we try to maximize the positive and minimize any flaws. I know this all too well because, while I don't mind the way I look in the mirror, there are only a handful of shots of myself that I really love—and many of them I set up myself. The reason is exactly what we have been discussing: most snapshots are done from a low angle with a wide-angle lens. If you have a big head like mine, it is going to be really big when photographed that way!

Our studio is extremely sensitive about using all of our tools to make someone look their best. Let's say, for instance, we have a full-figured bride who has a beautiful face. To photograph her, we'll use a high angle and do a close-up headshot that crops out most of her body, and she'll love us for it. If we have a groom with an unusually large nose, we'll avoid doing many profile photos with him. It sounds like common sense, and it is—but you would be surprised how many photographers don't employ these tricks.

Posing Basics

Not all of our wedding clients are models. Typically, they do not have an arsenal of poses in their repertoire. Sure, they may giggle if you

TOP—Shooting from a high angle is flattering for most subjects.

BOTTOM—This bride's left arm creates a base for the portrait. Her right arm and beautifully posed hand draw the viewer's eye to her face.

ask them for Ben Stiller's Magnum or Blue Steel pose (from the movie *Zoolander*), but that is about it. They usually need a little direction.

We are all about real moments, but we also want to capture some stylish fashion images, so we are not embarrassed to say we are posers. Early in my career, Disney sent me to study with Monte Zucker and Clay Blackmore. I would drive to Sarasota once a month and attend classes and spent a substantial amount of time learning how to get the bride's wrists to look just right. This, although beautiful, seemed a little excessive in the world that the great Tony Corbell coined "Guerrilla Wedding Photography." There was, however, a lot of good that came out of these classes. I learned to put people together quickly and with good aesthetic results.

I also learned how subtle refinements can make a huge difference and that hands and feet are crucial to a good portrait. I used the knowledge gained from these sessions to develop my own style: stylized fashion/documentary.

Posing the Groom

When photographing grooms, we like to have him lean against a wall, cross his ankles, and put his hands in his trouser pockets. This pose has a contemporary look, and having him lean on something tends to relax him. We tell him to act like he's waiting for a bus.

The positioning of the feet and hands is critical to this portrait. Having the groom cross his ankles puts his body in the perfect masculine pose. This provides the foundation for your portrait. Whether to place the hands in or out of the pockets has been debated forever, so do what looks good to you. Remember, though, that your portrait can be ruined if your subject does something strange with his fingers and ends up looking like he only has two digits on his right hand—and having his hands in his pockets can prevent this problem. Another technique is to have them close their hands loosely

Using a banister helps get the groom into a perfect masculine pose.

as if they had a golf pencil clasped inside. You could even have one hand in the pocket and the other at the side.

Normally, we demonstrate the pose. This is a huge time saver. If you show them what you want them to do, they get it instantly. From there, we kind of let it happen. If they deviate a little but it still looks aesthetically pleasing, that's fine. Hard-and-fast posing rules are a thing of the past. The hand police have all retired. We are just trying to make a nice-looking portrait in a timely way.

Another pose we like to use for the groom is where he is leaning on a rail or chair. Again, the groom's feet and hands must be refined. Even if his feet are not in the photograph, it is important to cross them because it naturally places his upper body in the correct position. Typically, you want to light the short side of the face. This creates a slimming effect.

Posing the Bride

The pose we use most often for the bride harkens back to a famous sculpture, the *Venus de Milo*. This pose starts with the bride's feet in an L position. This pose works with either the right foot forward or the left forward, whichever features your subject best. In this example, we'll assume her right foot is forward. With her

weight slightly on her back foot, her shoulders and torso will normally turn to the right. We then bring her chin back to the left, her flowers to one side, and her free hand to the other side. As with the guys, watch for splayed or awkward finger arrangements; these will ruin your image. This is the feminine pose. It is a tried-and-true form that you would do well to learn. As with the masculine pose, we demonstrate this pose for the bride. It is usually good for a laugh.

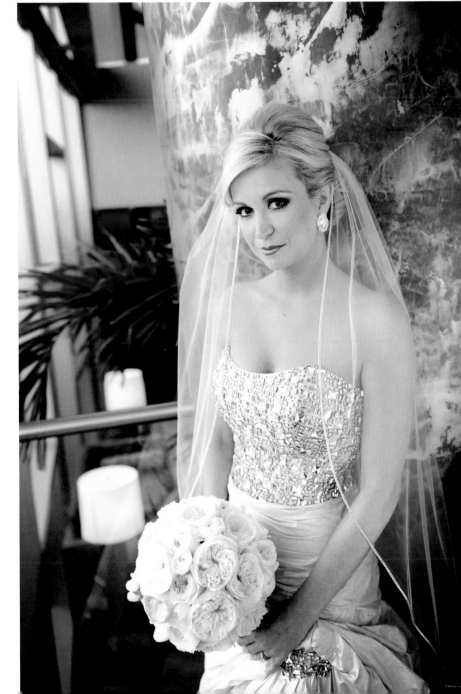

Turning the body slightly from the camera is visually slimming. Here, the bride's head and eyes were turned ever-so-slightly back to the camera for a finished look.

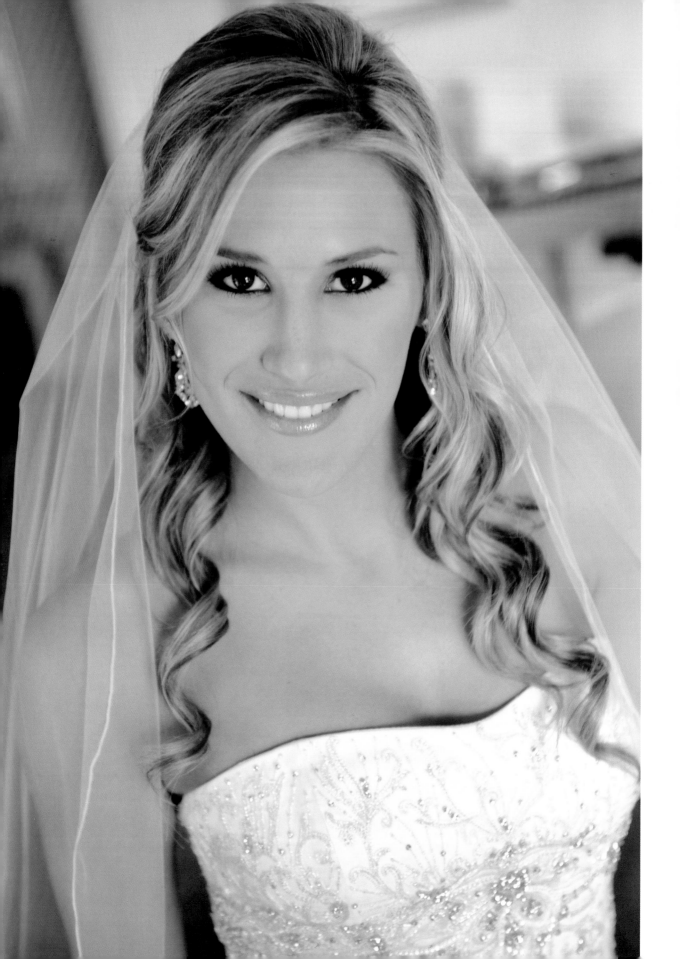

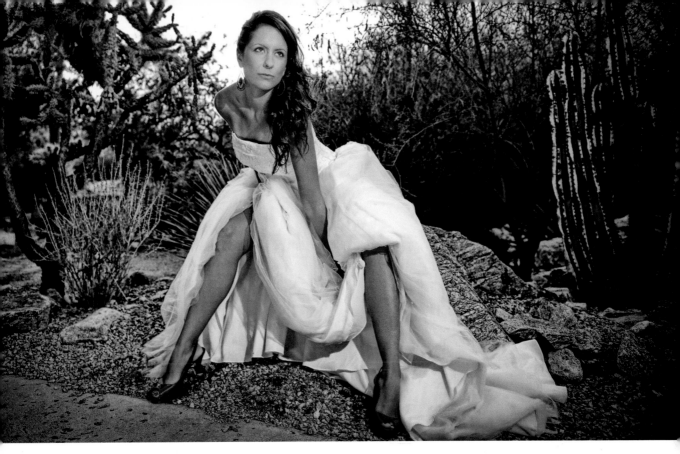

FACING PAGE—Positioning the feet in an L position helps to build a successful pose—even when the full length of the body is not shown in the image.

ABOVE—Poses with a contemporary, fashion-inspired feel appeal to many of today's brides. Look to ads and fashion magazines for posing inspiration.

A modern variation of this pose is to have the bride lean on a wall and cross her ankles. If she is not heavy, you can shoot her more square-on for a contemporary fashion look. Another variation of this pose is the seated bridal portrait. Chaise lounges are great for this shot in which the seated bride sweeps her crossed ankles to one side, leans forward, and brings her chin to the side of her body opposite her feet.

Another pose that we employ with the bride is a shot from behind that showcases the dress. Typically we like to do this in front of a window.

Once again, the bride's feet are in the L position with her back square to us. You can break this rule and just have her look out the window naturally. Both approaches are effective.

If your clients happen to look like supermodels, you can shoot from a very low angle with a fashion pose.

Lastly, if your clients happen to look like supermodels, you can shoot from a very low angle with a fashion pose. This creates a very dynamic image, but it is not for overweight clients.

Posing the Couple

The next challenge is photographing the bride and groom together. This is essentially a combination of the two previous poses, but there is a

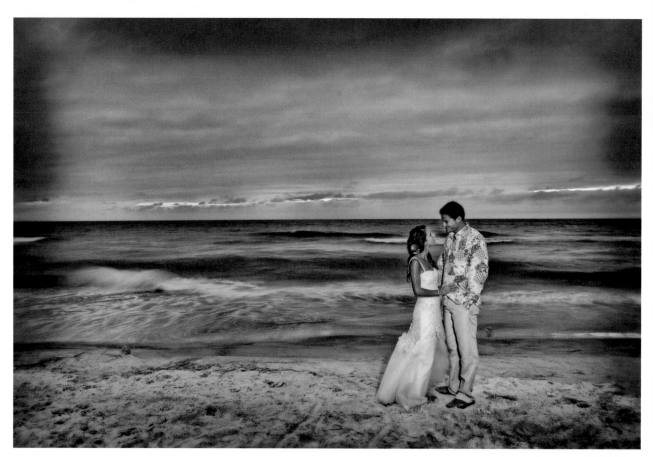

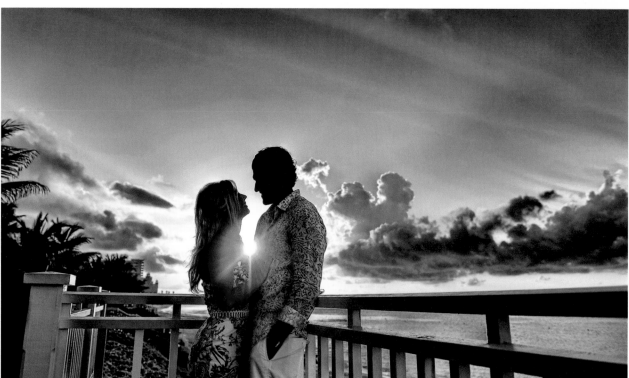

TOP AND BOTTOM—The same posing strategy was used for both of these images. The groom is in a casual pose, with his left hand in his pocket. The bride was brought close, with her hand on his torso. The diagonal line formed by her arm leads the viewer's eye upward. An implied diagonal between the subjects' heads directs the viewer's eye from one face to the other. It's a romantic, intimate pose. The difference in the cropping, the scene, and the position of the couple produces a different feel in each image.

ABOVE AND RIGHT—Have some fun with your posing, if it suits the couples' style. Couples need not be intertwined in every image. Consider posing the bride in her own space and the groom in his. Casual poses and fashion poses are both effective options.

little variation with the groom. To simplify this, we will begin by putting both the bride and groom in L poses. *(Note:* The groom is typically on the right because he has a boutonniere on his left lapel. There are no rules, however. If the bride looks better on the other side, put her there. If the boutonniere bothers you, take it off.)

Then, have them place their inside arms around each other's backs. Again, hand placement is critical. Be careful not to let their hands go around each other too far, and don't let them place their hands on each other's shoulders. Models can pull this off, but with the bride and groom, these misplaced hands can look like strange growths emanating from their

bodies. The safe bet is for the groom to put his hand on the bride's rear and for the bride to put her inside hand on the small of the groom's back.

To finish the pose, the groom simply puts his outside hand in his pocket and the bride places her flowers down low on her outside hip. Voilà!

From here you can do a number of variations. For one shot, ask the bride and groom to look at each other while not moving their bodies, just their heads. That's one shot. Then have them lean in and kiss. That's another shot. We also like to have the brides and grooms lean on walls. We might even have the groom lean on a lamppost and the bride lean in. These are all variations of the L pose.

Another thing to be mindful of when posing brides and grooms is the way they fit together. What we mean by this is that usually their heads or bodies are not the same size. There are strategies that you can use for a more harmonious couple's portrait. For instance, whatever you put closest to the lens generally appears larger than something farther from the lens. This is exacerbated with wide-angle photography.

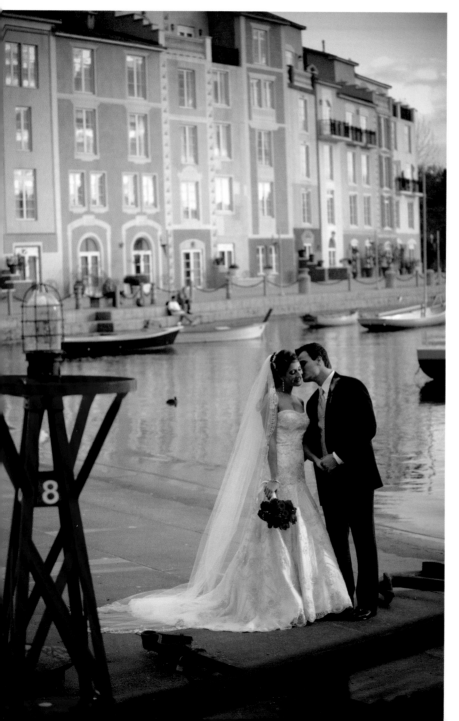

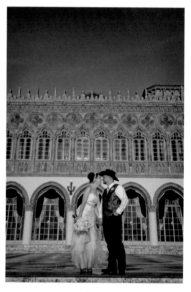

LEFT, TOP AND BOTTOM RIGHT—An L pose provides a great starting point for a variety of poses.

FACING PAGE—A great pose and striking composition combine to create a breathtaking image.

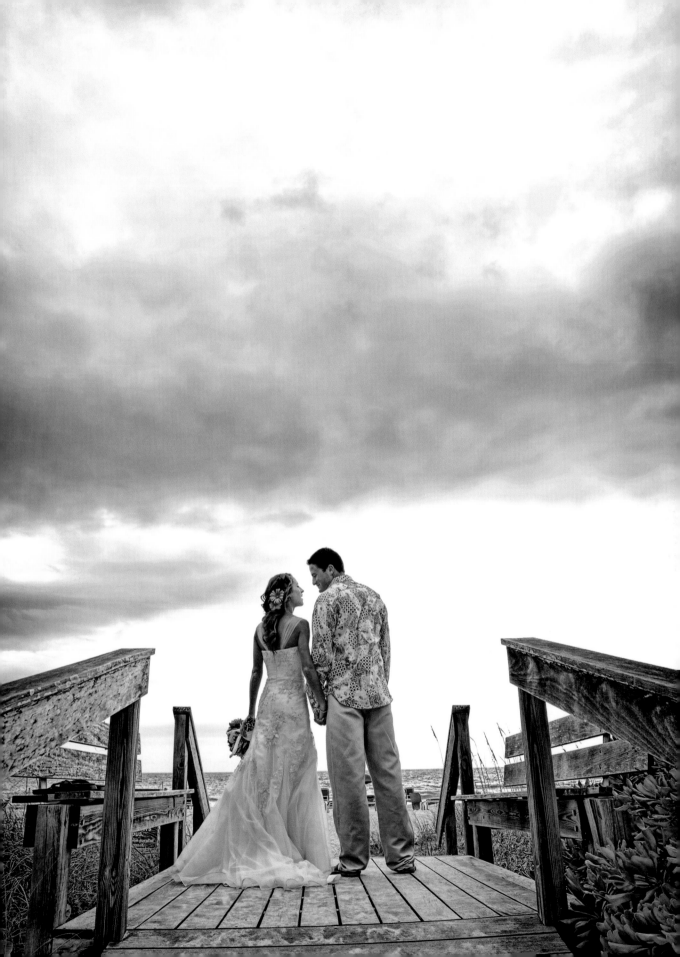

Let's say that you have a groom with a smaller head than the bride. If you place her closer to the camera than him, it will further accentuate this discrepancy. If, however, you simply switch them, it will work much better. It is just common sense, but this mindfulness of people's features will serve you well.

To diminish the size of your subject relative to their partner, have them positioned an inch or so back.

Similarly, in the side-by-side L pose, if you want to diminish the size of your subject relative to their partner, have them positioned an inch or so back. This technique does not work all that well with telephoto lenses, but with wide-angle and medium lenses it can make a dramatic difference. Remember, we are trying to make these people look good.

Posing Groups

The side-by-side L pose is also the building block for all the family portrait and group shots—just keep the bride and groom in place for each shot and position other subjects around them. Be sure to tell the bride and groom that they should hold their positions, as you are under time constraints. It just wastes time if the bride or groom goes off and starts chatting with someone. It is better if they just hold their pose and you keep building on it.

We start with the parents. With the groom's hand in his pocket, we have the mother grab the groom's outside arm as if he were escorting her down the aisle. The father steps around the dress (typically these shots are waist up), then puts his hand on the small of the bride's back,

carefully making sure to go under the veil and not to pull on it. The veil has some nasty plastic spikes to keep it in place and it can really hurt the bride if someone pulls on it. There it is—the parents' shot is done.

After the image of the parents alone, we usually photograph the immediate family. Typically, this includes Mom and Dad, brothers and/or sisters, and the bride and groom. Usually, we have the mom posed next to her son or daughter, then place the dad outside of the mom. The brother and/or sister will be on the opposite side, usually with the sister on the inside and the brother on the outside. The gentlemen on the end will have their outside hands in their pockets. This gives the shot a finished look. They will have their inside hands on the small of the back of the person beside them. This is how we do the family shots quickly and easily.

The next pose you will have to execute is the bridal party shot. It, too, is just a minor variation of what we have been talking about. The bride and groom will remain in the L pose and we will build upon that. For this shot, there may be up to twenty people. For large bridal parties (or any large group shots, for that matter), it is imperative to have steps or levels to help with posing. Otherwise, you just have twenty people lined up like Hands Across America (of course, that might make for an interesting panoramic image). Fortunately, churches usually have at least three or four steps or levels somewhere.

What we do is place the bride or groom on the top level. Then, we place the maid of honor and best man next to the bride and groom. We will then have the bridesmaids sit on the steps in a pose that is similar to the seated bridal pose. Flower girls and ring bearers are typically in the middle in front of the bride and groom.

When it comes to today's posing, the old "rules" have flown out the window. Let the bride be herself and use whatever pose makes her look great.

We then have the grooms-men fill in the rest of the steps. Another technique you can employ is to have two grooms-men drop down on one knee and place a bridesmaid on the other knee. If your group is too large or you have no steps or levels handy, you can always try to find a high vantage point, such as a balcony or ladder, and shoot down on everyone.

Relax

There are no hard-and-fast rules on posing anymore. In my opinion, it can be overdone and stifling when executed too precisely. I prefer to offer suggestions and try to let the people be themselves and relax. Our photographers are mindful of the end product and only make refinements when we feel it is in the best interests of our clients. These posing techniques are just tools to help you move more effectively and quickly at your events.

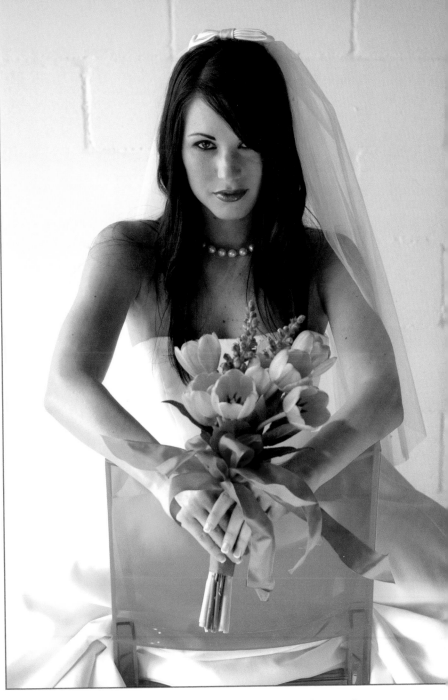

11. Lighting Techniques

*W*hen creating wedding photography, there are three types of light to consider: ambient light (also called available light),

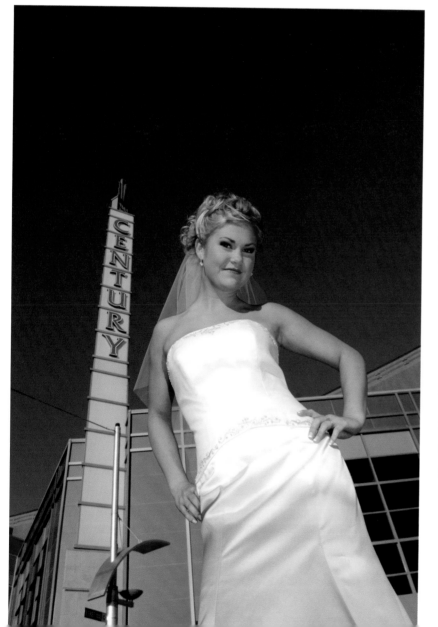

Adding a little fill flash on the bride helped keep the colors in the sky rich and dramatic.

There are three types of light to consider: ambient light, strobe, and continuous light.

strobe (off-camera flash or off-camera flash with speedlights, AlienBees, and Profoto B1), and continuous light (video LED lights). We use a combination of all three lighting types to achieve our results. We favor available light for wedding photography because of the time constraints that are in place. However, meticulously crafting an image with strobes placed at just the right angles to achieve three-dimensional results

We favor available light for wedding photography because of the time constraints that are in place.

on a two-dimensional plane is also very rewarding. You can get these three-dimensional results when working with available light, but you will definitely have more control if you have the time (and assistants) to light every portrait with an artificial lighting setup during the wedding. We employ speedlights off-camera with high-speed sync to create dramatic results. We also use AlienBees with a Vagabond Mini and the Profoto B1—it's a portable and powerful setup. As the wedding photographer, you must constantly make compromises, though. Our studio tries to work as lean and mean as possible. That is our mantra, but you must decide what is right for you and your clients.

Studio Strobes

Strobes are capable of outputting a lot of light, which means you can shoot at a lower ISOs and a smaller aperture (e.g., f/8 or f/11). The downside is the need to transport and work with extra gear—and that can really slow you down. There are times when they are simply the best light source for the job, and savvy

PRO TIP

To set up for post-ceremony portraits, we move our gear to the front of the church while the guests are exiting (people seated at the front of the church typically leave first).

An exposure of f/4 at $^1/_{50}$ and ISO 800–1600 exposure works great for me when I'm shooting group portraits at the altar. Even at f/4, I have sufficient depth of field because I am using a wide lens (around 24mm). I usually handhold the camera for these shots.

photographers should have them and know how to use them.

When studio strobe is required, we use an AlienBees remote setup or ProfotoB1 (see page 111). This allows us to work without cords, but the gear is heavier than a reflector.

On-Camera Flash

When we do use flash, we like to use it in conjunction with the ambient light. For instance, at most receptions we will shoot anywhere from 800 ISO to 1600 ISO. Our flash—an SB-800 Speedlight—is mounted on camera and modified with the Stofen Omni Bounce diffuser. Our typical exposure is f/4 at $^1/_{50}$ second. This works great because it allows the room light to expose the image, while the flash provides just the right kiss of light on the subject. In this situation, though, the subjects must be in a single plane of focus. In other words, you can't have a subject in the foreground and someone else in the background. If you did, the foreground person would be too hot and the background person would be too dark. Think of the light as water being thrown on the subject—you'll want to get everyone equally wet in this instance.

We work with our flash in TTL mode. We start without any exposure compensation but adjust the power to suit the scene, sometimes turning the unit down two stops.

For family shots, if you use a tripod, you can get away with shutter speeds of $^1/_{15}$ second or longer if necessary. If a subject moves, however, they may be blurry. Take enough shots to compensate for this—or, better yet, shoot at $^1/_{50}$ second or faster.

Off-Camera Flash

Speedlights. Off-camera flash has long been used to create flattering, dimensional lighting. With the flash off the camera axis, we can sculpt the subject's features and create a three-dimensional representation. In recent years, speedlights such as the Nikon SB-800, Nikon SB-910, and Canon equivalents have been all the rage. They are perfect for wedding work, as they are small, lightweight, and easy to carry.

Off-camera flash has long been used to create flattering, dimensional lighting.

Using speedlights, we are able to shoot wide open apertures like f/2.8. This allows us to use the Sunny 16 rule to get beautiful blue-sky photos. The Sunny 16 rule states that we can get a good exposure on a sunny day if we set our camera's aperture to f/16 and set our shutter speed to the reciprocal of our ISO setting.

For example, we can shoot at f/16, ISO 100 and $^1/_{125}$ second ($^1/_{125}$ is the closest traditional shutter speed to $^1/_{100}$). If we want to shoot wide open, we can calculate an equivalent exposure. To do so, we'd count the number of stops between f/16 and f/2.8—five stops—and make a corresponding five-stop adjustment to the ISO. The chart below shows the progression.

The aperture, ISO, and shutter-speed combinations below are equivalent exposures, meaning that the same quantity of light is allowed into the camera to create the image. However, each image would look different because of the different aperture/shutter speed combinations.

High Speed Sync. A camera's flash sync speed is typically $^1/_{250}$ second. If you were to shoot at a faster shutter speed, part of the image would be obscured by the moving curtain (this is sometimes called the barndoor effect). With speedlights, you can shoot using high-speed sync mode. This means you can use a shutter speed faster than $^1/_{250}$, which will allow you to shoot with a wide-open aperture. (I like to shoot at f/2.8 or f/4.) It is my opinion that the speedlight can more easily deliver f/2.8 than f/22. I position the speedlight, with no diffuser, as close as possible to the subject without being in the photo.

Using high-flash sync is a great way to create dramatic looks. Not only can you expose for the ambient and then light your subject appropriately, but you can underexpose your ambient by .5 to 2 stops for other creative lighting effects.

When you are working with off-camera flash, you will need a way to communicate with the flash unit, to tell it when to fire. You can use the line-of-sight system in your camera or rely on a triggering system like the RadioPopper PX.

EQUIVALENT EXPOSURES (AT ISO 100)

f/16 at $^1/_{125}$
f/11 at $^1/_{250}$
f/8 at $^1/_{500}$
f/5.6 at $^1/_{1000}$
f/4 at $^1/_{2000}$
f/2.8 at $^1/_{4000}$

The line-of-sight system is the easiest way to get your feet wet, but it has limitations—you must work at a relatively close distance and the flash sensors will need to "see" each other (see your user's manual for more information). Using a triggering system allows you to fire multiple flash units, even from great distances.

AlienBees Remote Setup. Another way that I like to shoot off-camera flash in the field is with my AlienBees remote setup. My setup consists of an AlienBees 800 monolight with a Vagabond Mini battery, Larson softbox, and a light stand. I tend to use this most often for bridal portraits and e-sessions (engagement sessions), as it's more equipment than I want to tote around on the wedding day, and there is more time to work with the lighting. However, I do keep it in the car, just in case.

Profoto B1. The Profoto B1, a new mono-light on the market, is wireless and offers loads of power for such a small package. I have been testing these lights in swamps, deserts, every-where—and I really like them. I use them with and without modifiers. They also have an LED

PRO TIP

Nikon users can select the high-speed sync option by going to Menu>Pencil Icon>Bracketing/Flash>Flash Sync Speed>$^1/_{320}$ (auto fp). With the Nikon D700 and D800, the remote flash can be triggered using the line-of-sight method with the built-in flash.

RIGHT—Using a speedlight and a high-speed sync exposure can allow you to create dramatic results.

BELOW—The original scene shows how lackluster a straightforward exposure might have been.

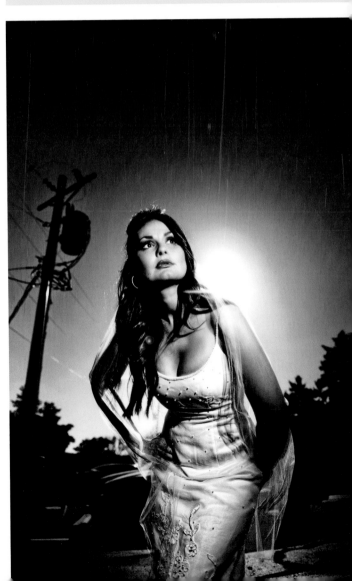

modeling light that can be used as a video light if desired. These are truly the Ferarri of lights and they make portable studio lighting in the field a breeze. They charge like you were charging your phone.

When using the AlienBees setup, I use RadioPopper Jrs. to trigger the flash. The Alien-Bees 800 gives me plenty of power and, with

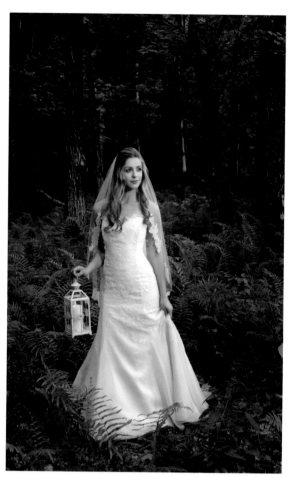

The Profoto B1 is an ideal light source for location work.

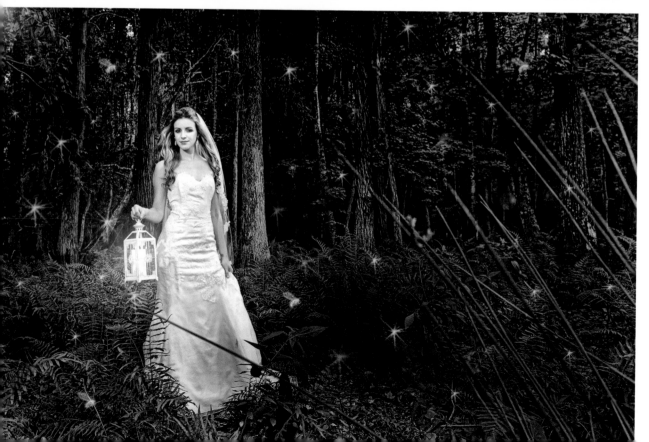

TOP AND BOTTOM—The Profoto B1 is powerful and compact, making it an ideal light source for wedding photographers.

the softbox, the light is beautiful, and I can create studio lighting effects in the field. I cannot shoot faster than $^1\!/_{250}$ second, however, so high-speed sync is not an option. The Profoto B1 was introduced in early 2014. Canon shooters can use an amazing proprietary Profoto transmitter. I'm a Nikon user, and I use my trusty RadioPopper wireless transmitter, but Profoto will soon have the Nikon version and they say they will be supporting high-speed sync capabilities soon as well.

Video lights produce a constant light—the light you see before you fire is exactly the light you will get in your final image.

Remember, the more techniques you know, the better you will be able to tackle any assignment. Off-camera flash gives your photos a crisp, dramatic look. It also allows you to change the mood of the scene by manipulating the background. Available light is awesome but it has another look entirely and does not give you the freedom to manipulate the environment.

Video Lights

Video lights—daylight-balanced LED panels— offer enough power for working in the studio or in the field. They work especially well in low-light situations (e.g., at twilight and in hotels and reception halls). They are a constant light source, which means "what you see is what you get" (WYSWYG, pronounced wizzy wig). They are, in my opinion, faster and more precise than using flash, and they come in a variety of sizes and power options. (As the name implies, they work well for video capture, too!)

The Fotodiox 508a retails for around $289. It operates on two Sony video camera batteries (supplied with the unit) or an A/C adaptor. This light unit packs a punch, but it can be bulky for use in the field.

I also like the Litepanels Micro. It's small, versatile, and fits in my ShootSac. It has a rheostat and operates on four AA batteries.

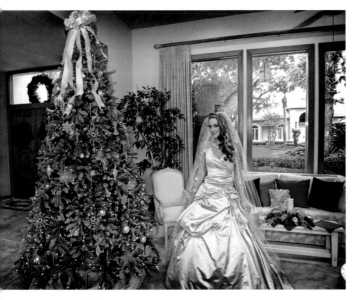

If you are on a budget and looking to get your feet wet, check out the Flashpoint On-Camera 160 LED Video Light—a dimmable unit that costs under $50. It features an articulated stem, allowing you to direct the light wherever it's needed. It can be powered by six AA batteries or rechargeable video batteries.

Available Light

Available light—the light that readily exists at a location—produces a more natural, flattering effect than that created by on-camera flash, which can look flat. Once you embrace it, available light is also an excellent time-saver, too.

The key to using natural light successfully is training your eye to see it. Good places to find available light include overhangs, locations where light is reflected from a building, window light, and on the shady side of buildings.

For room shots or architectural establishing shots at night, a steady tripod is a must. I don't feel comfortable handholding my camera without a flash for anything longer than a $1/100$ to $1/60$ shutter speed. The tripod allows me to drag the shutter as long as I want while restricting camera movement and keeping the image tack sharp. Some photographers hate using tripods; I'm not one of them. The tripod doesn't slow me down—it enables me to capture vibrant, dynamic, low-light shots with confidence.

Additionally, for portraiture, I like to shoot at f/2.8 for very limited depth of field—sometimes as little as two inches. Consequently, if I move just an iota, the image will be soft. I have been shooting at f/1.8 with prime lenses with the sun backlighting the subjects. The focus is on the eyes, as depth of field is sparse. This technique will throw any background completely out of focus and can help minimize distractions.

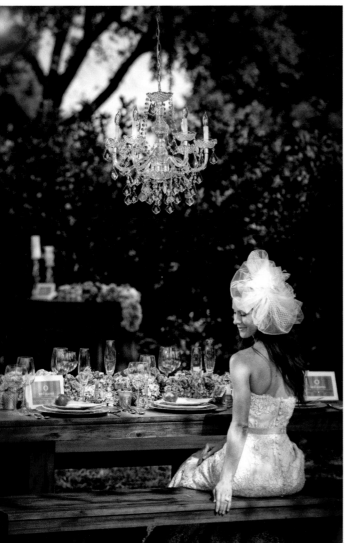

TOP AND BOTTOM—Working with available light allows you to capture great photographs quickly. This allows the bride more time to enjoy her wedding day with the people she loves.

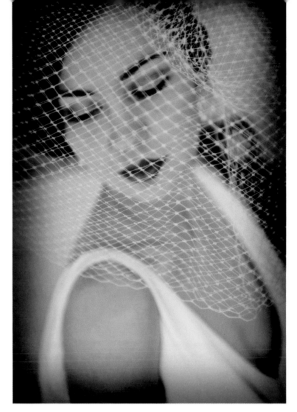

Window light and a reflector were used to create the soft and flattering light on the subject.

A reflector is useful when shooting in available light. In open shade and window-light areas, we usually employ a large silver reflector to accentuate the light on the subject's face. I often do a signature head shot of the bride using available light and a reflector. It's a simple approach, and an excellent portfolio shot of the bride can be had in about three minutes.

Open Shade. Open shade is the ideal available light, for two reasons: First, your subjects won't squint. Second, the lighting is less contrasty, so your camera will be able to capture a full range of tones. Full sun has its place (especially during outdoor ceremonies, for beach shots, and in blue-sky images), but in most cases, you should seek open-shade areas for the most flattering results.

Light Positions

We have talked about different types of light; now let's talk about different light positions.

When photographing a bride and groom together, you will usually want the light to come from the bride's side. In most cases, the bride is smaller than the groom, so if you did it the opposite way, he would block the light falling on her.

Remember to light the individual bride and groom portraits, whether with strobe or reflector, from the short side. The camera can add weight to your subjects. We tend to use a high camera angle to minimize this, but lighting the short side of the face further slims our subjects.

Some of the traditional lighting patterns used in portraiture are also used in wedding photography. The first is Rembrandt lighting, which is named after the famous painter. This is denoted by a triangle of light on the shadowed side of the subject's cheek. This is created when the main light source is above face height and at a 90- to 45-degree angle to the subject. The second common pattern is short loop lighting, indicated by a small loop-shaped shadow under the side of the subject's nose opposite of the main light. This is created when the main light is above face height and at less than a 45-degree angle to the subject. The final lighting pattern, called butterfly or clamshell lighting, creates a butterfly-shaped shadow directly under the nose. This is produced when the main light is directly above the subject's face. The approach is generally employed for beauty shots (usually with a fill reflector added below the subject's chin). In the run-and-gun world of wedding photography, we will mostly use variations of the short loop and butterfly lighting techniques with an occasional Rembrandt thrown in.

12. Image Capture

When photographing a wedding we like to keep it simple—but we're not afraid to shoot the heck out of it. Typically, we present sixty images per hour of coverage in our online proofs and in proof magazines (essentially bound contact sheets). We usually whittle that down to a total of 250 images that we use in a viewing/sales session. Of course, we shoot many more images than we show. It may be time-consuming to do the editing, but it is better to have what you wanted rather than to have to explain why you don't. Besides, CompactFlash cards are quite economical now (we shoot with 32G cards), so there's no reason not to bring more than you need just so you'll never be afraid to over-shoot.

File Formats

When I first started shooting digital, I found working with RAW files to be very cumbersome—but then, I was trained in exposure techniques for slides and transparencies, so I was able to reliably produce great results with JPEG files; I watched my histograms and bracketed.

With the advent of Adobe Lightroom, our studio began shooting RAW files more often. Usually, however, we shot RAW + JPEG and only went back to the RAW file if necessary—we used the RAW file mainly as a safety net. Today, we have started shooting even more events in RAW + JPEG, and we feel that novices would behoove themselves to do so as well. We are still vehement about getting each exposure as perfect as possible, but the benefits of shooting

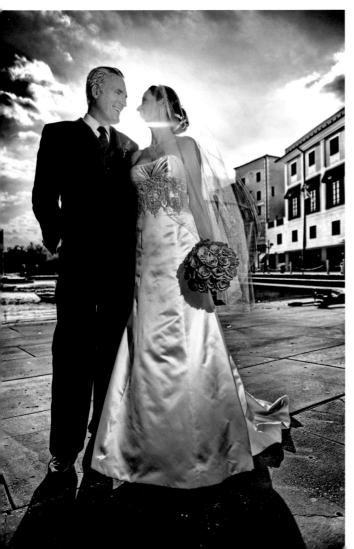

For maximum control over our images in postproduction, we like to shoot RAW + JPEG.

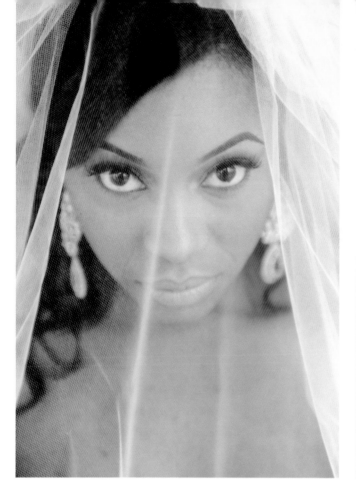

LEFT AND RIGHT—Shooting RAW files will give you great control, but careful exposure techniques can also allow you to obtain excellent results when shooting JPEGs.

RAW are many. Color correction is a breeze and exposures that in JPEG-fine would be useless can be saved and brought back to life. The sharpening and batch-processing features are also incredible. Shooting in RAW does, of course, have its drawbacks in terms of storage—but storage is becoming cheaper every day.

Ultimately, RAW processing will give you phenomenal control over your images and push your creativity to the limits. Embracing new workflow tactics is hard, but savvy wedding photographers will keep themselves current and armed with the latest tools. Adobe Lightroom is no passing fad, and it has taken our imaging to new heights.

Exposure

You know what they say: "Garbage in, garbage out." That is especially true when it comes to digital files. There is no substitute for having a solid exposure to work with.

I am meticulous about exposure because when I started dabbling in photography, I had a Nikon FE SLR that was given to me by my dad. The meter in the old film SLR did not work so well, so I would line up the arrows like my father taught me . . . but my results were lackluster at best.

Later, another mentor of mine, filmmaker Glen Lau, showed me the recommended

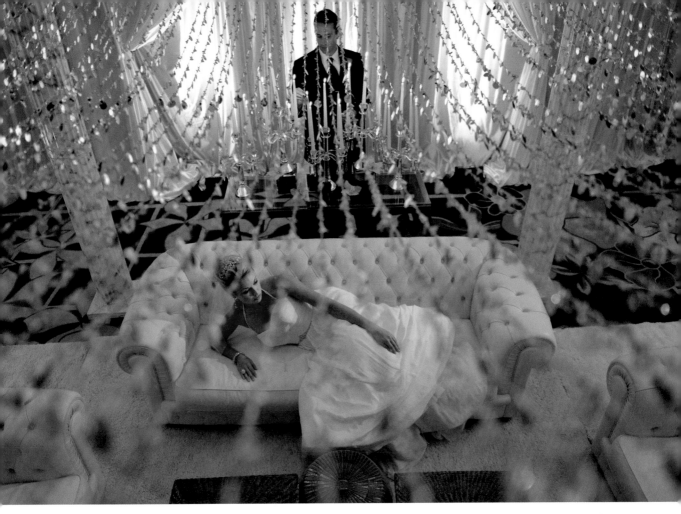

This image was captured with a Nikon 24–70mm f/2.8 lens. The focal length was 26mm.

exposures that were printed on the film boxes. He also gave me a chart of relative exposures. As it turned out, the film boxes and charts basically gave you the optimal exposures for a variety of different situations. These are outlined in the chart below.

By practicing with these settings, and their relative equivalents, I became something of a human light meter. Nowadays our cameras'

RELATIVE EXPOSURE GUIDE

Bright sunlight on sand or snow . f/16 at $^1/_{250}$ second and ISO 100

Bright sun with distinct shadows . f/11 at $^1/_{250}$ second and ISO 100

Weak, hazy sun . f/8 and $^1/_{250}$ second and ISO 100

Cloudy .f/5.6 at $^1/_{250}$ second and ISO 100

Heavy overcast .f/5.6 at $^1/_{125}$ second and ISO 100

Inside church or restaurant (PM)f/5.6 at $^1/_4$ second and ISO 400

meters are incredible, but it doesn't hurt to have a working knowledge of the light around you and to have a reference point to start from. Even with all of our technological advances, these basics create a solid foundation to build upon.

Lenses and Focus

We find that digital photography has some issues with focus. In a series of shots, one image is often inexplicably "soft." Overshooting a tad compensates for this, but sharp focus is something we are always very mindful of. There is nothing more disappointing than taking a great image and finding that it is too soft to use.

We tend to shoot wide open (f/2.8–5.6) . . . it allows us to maximize the ambient lighting.

With our Nikon systems, we found that some lenses were inherently sharper than others. Our favorite was the 50mm f/1.4 lens—an excellent lens for everything from food, to portraits, to weddings. The 24–70mm f/2.8 lens is an exceptionally sharp utility lens.

We tend to shoot wide open (f/2.8–5.6) because we like the shallow depth of field and it allows us to maximize the ambient lighting. When shooting like this, it is critical to focus precisely. We employ the spot focus method where you hold down the button with the focus on what you want, then recompose the shot. That is just what we like to do, though. At the end of the day, there are a lot of methods for achieving sharp images.

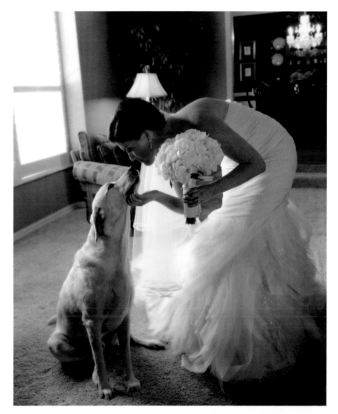

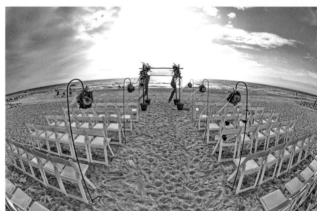

TOP—A 24–70mm f/2.8 lens was used to capture this image. The focal length was 31mm.

BOTTOM—A fisheye lens adds visual interest to a scene. that needs a little punch to really shine in the album.

13. Postproduction

Capturing a great image will no longer keep you competitive in today's wedding market. With the advent of digital photography, what you do afterwards is just as important—if not more so.

The images that we capture must be fiercely edited and polished to perfection.

The savvy photographer has an assortment of tools in his arsenal to help him do this in a timely and aesthetically pleasing manner. In addition to Photoshop, we use the tools discussed below to make our images stand out from the crowd.

During a typical six- to eight-hour wedding, my associate and I capture 2000 to 3000 images on 32G 1000x write-speed cards.

The images that we capture must be fiercely edited and polished to perfection.

This HDR image was created using software from Lucispro.com.

The original image (above) was transformed into a portrait with a more etherial feel using Topaz Lab's B&W Effects.

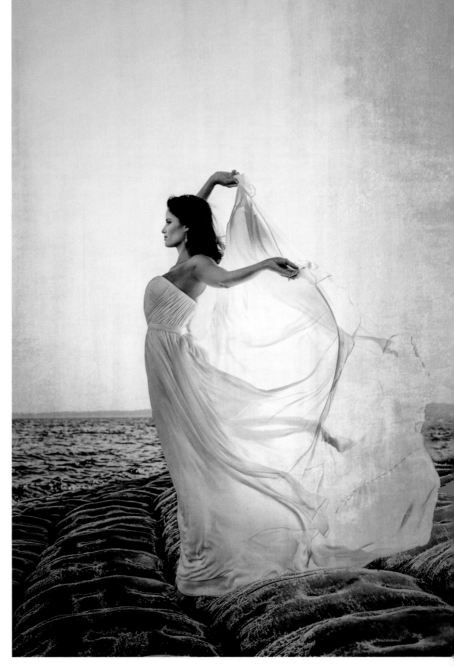

We shoot JPEG large and RAW simultaneously. I like the way the camera processes the JPEGs, and I try to get my exposures exact. I do have the RAW files, as I have a responsibility to my client to be sure I've nailed the shot, but we usually access less than 5 percent of those files for a wedding. We like to deliver 60 to 100 edited images per hour of the event, so for 6 hours of coverage, I usually deliver about 500 images.

I personally like to use Camera Bits' Photo Mechanic for culling and Adobe Photoshop and Adobe Lightroom for polishing. I use LucisPro's LucisArt and TopazLab's TopazAdjust for HDR or detail-enhancing effects. I also use a variety of actions, some of my own and others I have purchased from Florabella, Parker Pfister, Kubota Image Tools, OnOne, TopazLabs, and Totally Rad actions.

After the shoot, the files are downloaded onto our computer, sorted, and renamed. The JPEGs are backed up to DVDs. Once everything is edited and polished, it is uploaded to Zenfolio. Clients from around the world can view their password-protected images and order

a variety of products. Once uploaded to Zenfolio, the files are backed up and retrievable, providing a third backup of your client's images.

I like to provide a sneak peek of 25 to 30

I like to provide a sneak peek of 25 to 30 images on Facebook or my blog within three days of the event.

images on Facebook or my blog within three days of the event. Images from the entire event are posted online within three weeks of the wedding. At that point, the onus is on the client to select their favorite shots. Once the client has selected their favorite images, the layout is

completed within four weeks and placed online for the client to view. They are allowed four changes—after that, each change costs $25 each change. Once they approve of the album design and sign off, the album is sent to the album maker. I tell my clients that the printing process can take 3 weeks or 13 weeks (on occasion, the album must be sent back to have something fixed). Sometimes there are delays, and it's best to be honest about this. In my experience, when people are informed, they handle waiting better than they would if they anticipate receiving the finished album in three weeks' time and then find the photographer making excuses as to why the album has not arrived.

LEFT—Postproduction work can take your image to a whole new level of creativity. Here, LucisArt was used to add a detail-enhancing effect.

RIGHT—Cater the look of your final image to suit your clients' tastes. For this image, we used Kevin Kubota's actions to add a cross-processed look.

Conclusion

State of the Industry

Wedding photography is an interesting profession. I have been doing this for more than twenty years, and I see people come and go all the time. It reminds me of the gold rush—everybody is looking to cash in.

Well, if you take a look at PPA's studio management surveys, they will tell you that the average photographer makes about $33,000 a year. I have a great job that affords me the opportunity to go to my teenage daughter's soccer, basketball, and volleyball practices and games, bring her lunch to school when she forgets it, and be an active part of her life. I would say we are a comfortable middle-class family. I drive a 2001 Honda CRV with 200,000 miles on it (I love it!) so I can pay her Catholic school tuition. If you are looking to get rich, I'd caution you against entering the photo biz. There are much better ways to amass wealth. If you love photography, are willing to work hard, continually strive to be a better artist, and are ready to spoil your clients,

Wedding photography is not a get-rich-quick venture. If you love what you do and strive to connect with your clients and capture memorable moments for them, however, you're in the right field.

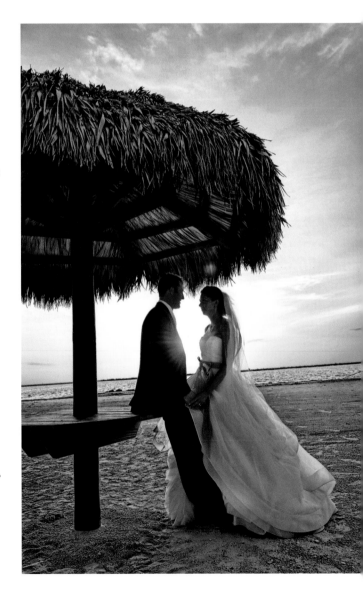

however, you'll find that this is an awesome profession.

These days, I shoot roughly twenty high-end weddings a year. I do not advertise, it is all word of mouth referrals. I am careful when it comes to managing my reputation. I work hard and take no shortcuts. Integrity, tenacity, and working hard are the recipes for success. Learn all you can about your craft, then learn all you can about business.

Finding Your Passion and Style

To really do this job well, you must be passionate about it. I love wedding photography for many reasons. Because I was trained as a generalist, I especially appreciate that shooting weddings allows me to implement so many types of photography. In a single event, I can go from shooting still lifes, to landscapes, to photojournalism, to portraiture, and even food photography. The wedding is one arena where your every passion for photography can really be unleashed, so if you don't feel passionate about it, you should probably choose another line of work.

Hand-in-hand with passion goes style. If you are to succeed in this business, you must find your own personal style. You must impart something of your personality—even your soul—into every image. Learn the basics, emulate your idols, then set out to find yourself. The end results will communicate much more realness than the cookie-cutter images that are all too often produced at weddings.

This is a process that never ends, so try to surround yourself with greatness, be it music, art, or literature. Consistently look for inspiration. Do not rest on your laurels. This industry is constantly evolving, and you will be left behind if you do not evolve with it.

This industry is constantly evolving, and you will be left behind if you do not evolve with it.

In addition to passion and style, savvy wedding photographers will arm themselves for success with solid skills. There are many tools available to do so. Organizations like Professional Photographers of America (PPA) and Wedding and Portrait Photographers International (WPPI) are valuable resources to beginners and seasoned veterans alike. Both have national conventions every year where photographers can experience camaraderie, print competitions, and a free exchange of ideas and techniques. They also have huge trade shows where you can get your hands

on the latest albums, cameras, and equipment galore.

PPA provides equipment insurance with its membership—$15,000 worth. As a bonus to its members, PPA also provides wedding indemnification, protecting you against any malpractice lawsuit that may arise. This is a huge asset for the burgeoning wedding photographer. We have a business insurance package through PPA that covers our equipment and studio space. We also have host liability insurance, as we serve wine to clients at our viewing sessions.

The artistic side of this profession is just one side of the coin. If you want to make a living as a photographer, you need to embrace the business side of it as well. Try not to go overboard with spending in the beginning. I worked out of the loft I lived in when I first left Walt Disney World, and I can promise you that having no overhead is a good thing! Take it slow and build a solid infrastructure. There is a lot more to being a successful wedding photographer than taking great images. Networking, marketing, and business plans all come into play.

Wedding photography may not be open-heart surgery, but clients take it just as seriously. Be responsible and embrace your craft to the best of your ability. Always strive to exceed your client's expectations. After all, who doesn't like to get the thirteenth donut in the baker's dozen? That's how we roll at Damon Tucci Studios.

Your clients entrust you with the task of capturing all of the beautiful details of their wedding day. Do your job to the very best of your ability, keep learning, and create breathtakingly gorgeous images!

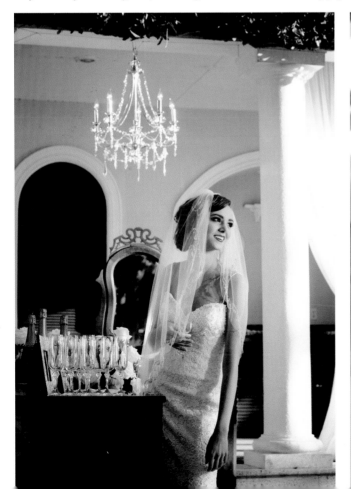

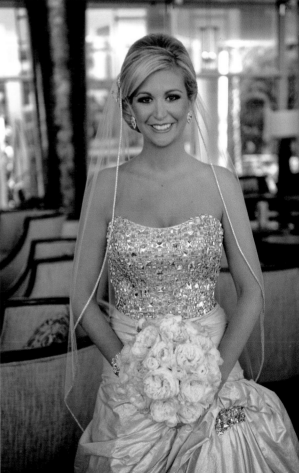

Index

OTHER BOOKS FROM
Amherst Media®

TUCCI AND USMANI'S
The Business of Photography

Take your business from flat to fantastic using the foundational business and marketing strategies detailed in this book. *$34.95 list, 8.5x11, 128p, 180 color images, index, order no. 1919.*

Elegant Boudoir Photography

Jessica Lark takes you through every step of the boudoir photography process, showing you how to work with clients and design images that are more engaging. *$27.95 list, 7.5x10, 128p, 230 color images, order no. 2014.*

Magic Light and the Dynamic Landscape

Jeanine Leech helps you produce outstanding images of any scene, using time of day, weather, composition, and more. *$27.95 list, 7.5x10, 128p, 300 color images, order no. 2022.*

Shoot to Thrill

Acclaimed photographer Michael Mowbray shows how speedlights can rise to any photographic challenge—in the studio or on location. *$27.95 list, 7.5x10, 128p, 220 color images, order no. 2011.*

Step-by-Step Lighting for Outdoor Portrait Photography

Jeff Smith brings his no-nonsense approach to outdoor lighting, showing how to produce great portraits all day long. *$27.95 list, 7.5x10, 128p, 275 color images, order no. 2009.*

Photograph the Face

Acclaimed photographer and photo-educator Jeff Smith cuts to the core of great portraits, showing you how to make the subject's face look its very best. *$27.95 list, 7.5x10, 128p, 275 color images, order no. 2019.*

The Right Light

Working with couples, families, and kids, Krista Smith shows how using natural light can bring out the best in every subject—and result in highly marketable images. *$27.95 list, 7.5x10, 128p, 250 color images, order no. 2018.*

Dream Weddings

Celebrated wedding photographer Neal Urban shows you how to capture more powerful and dramatic images at every phase of the wedding photography process. *$27.95 list, 7.5x10, 128p, 190 color images, order no. 1996.*

Light a Model

Billy Pegram shows you how to create edgy looks with lighting, helping you to create images of models (or other photo subjects) with a high-impact editorial style. *$27.95 list, 7.5x10, 128p, 190 color images, order no. 2016.*